IN SEARCH OF ROBERT E. LEE

IN SEARCH OF ROBERT E. LEE

Chuck Lawliss

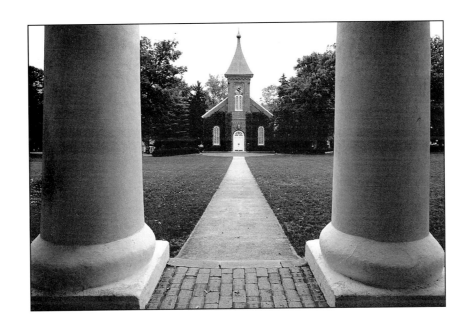

COMBINED BOOKS
Pennsylvania

First published in the United States of America in 1996 by Combined Books, Inc.

For information, address:
COMBINED BOOKS, INC.
151 East 10th Avenue
Conshohocken, PA 19428

Distributed internationally by Greenhill Books, Lionel Leventhal, Ltd., 1 Russell Gardens, London
NW11 9NN.

Library of Congress Cataloging-in-Publication Data
In search of Robert E. Lee / Chuck Lawliss
 p. cm.
 ISBN 0-938289-74-8
 1. Lee, Robert E. (Robert Edward), 1807-1870—Pictorial works.
 2. Lee, Robert E. (Robert Edward), 1807-1870—Homes and haunts—Pictorial works.
 3. Historic sites—Virginia—Pictorial works.
 I. Title.
 E467.1.L4L28 1996
 973.7'30'92—dc20 96-30219
 CIP

First Edition, First Printing, 1996
Printed in the United States of America

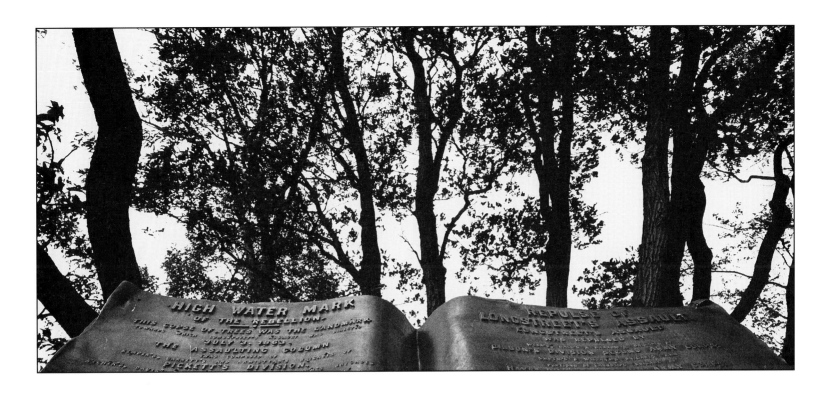

Contents

Introduction *9*

In Search of Robert E. Lee *13*

Epilogue *99*

Guide to Robert E. Lee Sites *101*

Index *117*

Of war I sing, war worse than civil,
waged over the plains of Emathia,
and of legality conferred on crime;
I tell how an imperial people turned
their victorious hands against their
own vitals; how kindred fought
against kindred; how, when the
compact of tyranny was shattered,
the forces of the shaken world
tended to make mankind guilty;
standards confronted hostile
standards, eagles were matched
against each other, and pilum
threatened pilum. What madness
was this, my countrymen?

Lucan (Marcus Annaeus Lucanus)
44 B.C. in *The Civil Wars (Pharsalia)*

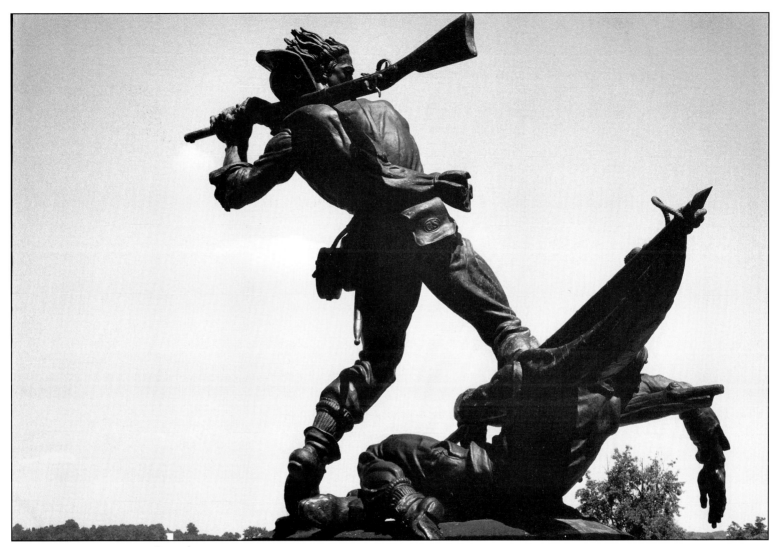

Louisiana Monument, Gettysburg

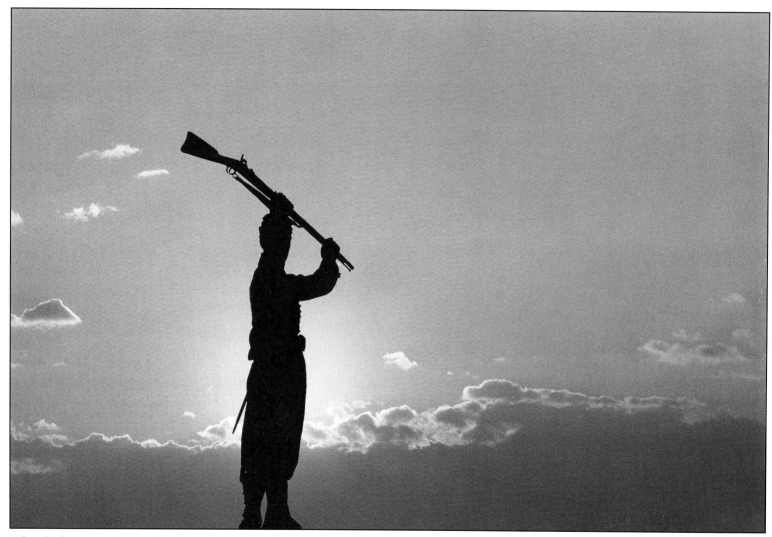

The 69th Pennsylvania Monument at Gettysburg

Introduction

A BRONZE EQUESTRIAN STATUE, identified by the one word "Lee," stands on Monument Avenue in Richmond, the capital of the state Robert E. Lee loved so much and sacrificed so much for. The statue on its pedestal stands sixty feet tall. This is imposing, but the statue is elevated too high to be seen properly. From the base, about all one can see is Traveller's stomach and the heels of Lee's boots. From a distance, the statue could be of any man on any horse. The author Henry James wrote that something in the figure suggested "a quite sublime effort to ignore, to sit, as it were, superior and indifferent...."

Like his statue, Lee sometimes seems to have been elevated too high to be seen properly, and at first glance, he does seem superior and indifferent. Yet few Americans have ever been so loved. The Confederate general, considered a traitor by many Yankees, a man whose citizenship was not restored until a century after his death, has become

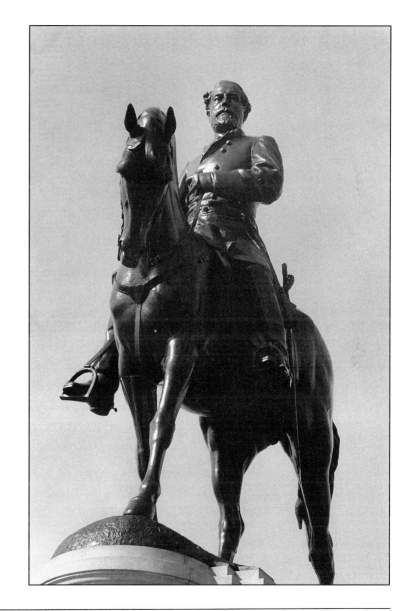

The equestrian statue of Robert E. Lee (right)*, by Jean Antoine Mercie, towers over Monument Boulevard in Richmond. A telephoto lens has accomplished what the naked eye can't—compress the distance separating the viewer from the statue so that it can be seen clearly. Over the years, biographers have attempted to do something similar—see beyond the legend to find something more—a flaw, a human frailty, a transgression. Can someone go through life without a demerit? Yet all they have found is a great man, deceptively simple in his greatness; a man who saw his duty and did it.*

one of the nation's greatest and most beloved heroes. Historian Thomas L. Connelly wrote, "To the postwar South, he was the rationale of the Lost Cause, the proof of the argument that the righteous do not always prevail. To the nation, Robert E. Lee became the tragic hero figure, who represented all that was good and noble in a bad cause."

Robert E. Lee was of heroic stature, no mistake about that. He was a brilliant and courageous general, a great gentleman, a man of honor, a devoted family man, and a loyal son of Virginia. But the image does becloud the man.

Douglas Southall Freeman, who said he passed the Lee statue almost daily and invariably saluted it, made a compelling case for Lee's greatness in his massive four-volume biography. "Robert Lee," he wrote, "was one of the small company of great men in whom there is no inconsistency to be explained, no enigma to be solved. What he seemed, he was—a wholly human gentleman, the essential elements of whose positive character were two and only two, simplicity and spirituality."

Not everyone found Lee that consistent. Mary Chesnut, who observed him during the war, wondered if anyone could really know him: "He looks so cold and quiet and grand." Bruce Catton agreed with her. "This gray man in gray rode his dappled gray horse into legend almost at once," he wrote, "and like all legendary figures he came before long to seem almost supernatural, a man of profound mystery." To Stephen Vincent Benet, Lee was "the marble man"—

A figure lost to flesh and blood and bones,
Frozen in a legend out of life,
A blank-verse statue—
For here was someone who lived all his life
In the most fierce and open light of the sun
And kept his heart a secret to the end
From all the picklocks of biographers.

One Lee biographer, Paul C. Nagel, writes, "At two points in his life he showed daring and imagination. These were on the battlefields of the Mexican War and the Civil War. But across the longer stretches of time, he seemed lethargic and inclined to stick with what was familiar and at hand." Indeed, his confidence in his generalship enabled him to face down every general he ever met in the war except the last one. And Ulysses S. Grant also possessed supreme confidence in his success as a commander.

Some critics write Lee off as "the last of the great old-fashioned generals." Yet Lee understood what was required for the Confederacy to win its independence, and he bent every effort to that victory, a most modern concept indeed. All the South needed to do was make the North tire of the war. A decisive victory at Sharpsburg or Gettysburg might well have led to a negotiated peace.

Total war is a modern concept. Lee once told an aide that "since the whole duty of the nation would be war until independence should be secured, the whole nation should for a time be converted into an army, the producers to feed and the soldiers to fight." The conscription bill of 1862, the first in American history, was largely of Lee's making.

Lee was a paradox. According to historian Stephen W. Sears, those who consider him a military genius and those who don't can agree on one point: The Confederacy might have been better off without him. Lee's detractors say he squandered the South's resources of men and materiel, and any chance of independence along with them. His admirers say that without him the Confederacy would have been defeated early, saving lives and suffering. Certainly the course of the war would have been quite different without him.

Lee never wrote his memoirs, as did so many other generals. Among the major figures of the war, he left the

fewest words. His actions, however, spoke volumes. Lee was a professional soldier who found his true calling in war. Bruce Catton said Lee "understood the processes of war as few men have ever done."

Before Lee took command of the Army of Northern Virginia, Porter Alexander, who would become chief of Longstreet's artillery, asked an aide to President Davis if he thought Lee had sufficient audacity to lead an army. "Lee is audacity personified," the aide replied. "His name is audacity, and you need not be afraid of not seeing all of it you will want to see."

Lee's audacity was responsible for most of the great Confederate successes. His audacity was also responsible for such defeats as Malvern Hill and Pickett's Charge at Gettysburg, but he extended the life of the Confederacy beyond all reasonable expectations.

Over the years, I have been intrigued by this man, and one day I went in search of him, I visited and photographed the sites associated with his life, from the crib in the room where he was born to the crypt in which his body lies. I walked old battlefields, explored old houses, and sat in classrooms where he learned his lessons. I also read dozens of books and articles about Lee, his family, and the generals who fought for him and against him.

My efforts were rewarded with a glimpse, not of a "marble man," but a great man who was touchingly human. He seemed aloof, true; shy men often do. Lee was not a public man. He shunned the spotlight. He never made a speech. He never wrote his autobiography, which could have earned him a small fortune. His General Orders No. 9, the famous farewell address to the Army of Northern Virginia at Appomattox, was written by Charles Marshall, his secretary.

I learned that Lee loved having his children tickle his feet while he read them stories in bed. He also loved band concerts, and once remarked, "I don't see how we could have an army without music." He enjoyed playing chess on his campaigns with his aide, Colonel Charles Marshall. For a board they used a pine slab, marked into squares with a knife, the black squares inked in. I also learned that this gentle man had a temper, and when angry would give telltale nervous jerks of his head. Although he avidly sought confrontations with the enemy, he avoided provoking personal confrontations; they made him uncomfortable. Yet he had no patience with subordinates who couldn't or wouldn't follow his orders. Those who failed him didn't stay with him very long.

Beyond his military genius, Robert E. Lee was a good man, an unselfish man. He genuinely cared for other people and tried to do his best for them. And throughout his life, he was able to rise above the frustrations that plagued him. Without complaining, he would analyze his circumstances and try to make the best of things. His life is an example to us all, and perhaps it is the greatest legacy of the cause he served so well.

IN SEARCH OF ROBERT E. LEE

Confederate "Stainless Banner"

*D*estiny's child was born on January 19, 1807, at Stratford Hall, one of Virginia's grandest plantations and the ancestral home of the Lees, one of the greatest families of America. He was the fourth child of Henry "Light-Horse Harry" Lee and Ann Carter Lee, who named their strong healthy boy Robert Edward, after two of his mother's brothers.

The boy fell heir to the best qualities of his distinguished family. From both the Lees and the Carters, he inherited a handsome countenance. From his mother came gentleness and a loving nature. From his father came rare physical strength and endurance. His father also set an example of physical and moral courage that became central to Robert's character. Even his father's money problems proved to be an object lesson: Lee would always be prudent in his financial dealings.

The boy's lineage suggested that he would do great things. An ancestor had fought beside William the Conqueror, and another was knighted by Queen Elizabeth. The founder of the American dynasty, Richard Lee, came from England in 1640 and served as secretary of state for the British governor, William Berkeley. Two signers of the Declaration of Independence, Richard Henry Lee and Francis Lightfoot Lee, had spent their childhood at Stratford.

Thomas Lee built Stratford Hall in the 1730s. Five of his sons were leaders of the patriot cause. John Adams called them "this band of brothers, intrepid and unchangeable, who like the Greeks at Thermopylae, stood in the gap, in defense of their country."

Over the years, the Lees separated into two aristocratic clans. The Lees of Leesylvania, were rich and active in politics. Lucy Grymes Lee, the early sweetheart of George Washington, was the mother of Charles Lee, Washington's Attorney General, and Richard Bland Lee, a noted Federalist leader.

Many people believed the Lee with the most promise was Robert's father, Henry "Light-Horse Harry" Lee, Washington's flamboyant cavalry leader. He had served in both the Continental Congress and the first Congress, and in 1791 was selected governor of Virginia. He gave the eulogy in Congress for George Washington, praising him with the famous words, "First in war, first in peace, and first in the hearts of his countrymen."

While pursuing his political activities, Harry Lee courted his cousin, Matilda Lee, the beautiful heiress to Stratford, and their marriage in 1782 reunited the two great Lee clans. The sudden death of Matilda eight years later left Harry Lee badly shaken, but he was determined to marry again. He became a frequent visitor to Shirley, the James River plantation of Charles "King" Carter, the wealthiest man in Virginia. His marriage to Ann, Carter's daughter, seventeen years his junior, cemented a kinship between two of Virginia's most powerful families.

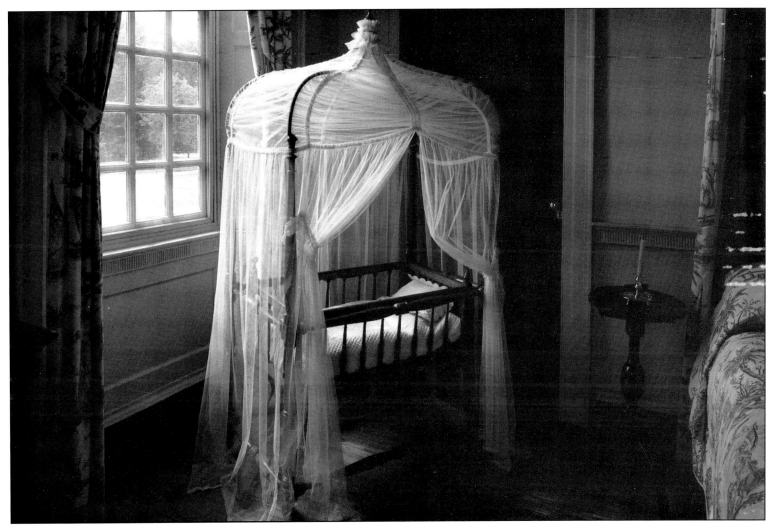

Robert E. Lee was born in this large sunlit room on the second floor of Stratford Hall. His mother, Ann Hill Carter, was one of the wealthiest heiresses in Virginia. She was twenty when she married Harry Lee, then the Governor of Virginia. A member of Congress when George Washington died in 1799, Lee delivered the funeral oration, coining the undying eulogy: "First in war, first in peace, and first in the hearts of his countrymen." Harry Lee's youth had been all glory, but his declining years would be increasingly miserable, and his wife and children would have to share his fate.

*A*fter the death of George Washington, Harry Lee's fortunes began to decline. He had been speculating financially for years. On her deathbed, his first wife had placed Stratford in trust to her children, fearful that he should sell the plantation. He lost a great deal of money in western land, and as Ann was presenting him with six more children, his financial resources were dwindling precipitously.

Money worries affected Ann's health, and she was bedridden for long periods. Harry's reputation had collapsed. He had even written George Washington a bad check. Hounded by creditors, he placed large chains across the doors at Stratford to ward off sheriff's officers attempting to serve him with papers. Most of the furnishings had been sold to pay debts.

While Robert was learning to walk, Harry was carried off to debtor's prison for nearly a year. In his cell, with characteristic courage, he wrote his *Memories of the War in the Southern Department of the United States*. When the book was completed in 1810, the family moved to Alexandria, where they were able to take up a new life on a modest scale.

Henry Lee IV, Robert's half-brother, became master of Stratford, but, unfortunately, he shared Harry's bad habits. His debts forced him in 1828 to sell Stratford for $11,000, and the plantation passed from the Lee family forever.

Harry Lee's last years were full of sorrow and pain. While defending a friend, he was beaten by a mob in Baltimore and suffered internal injuries that kept him in physical torment. He sought relief in the warm climate of Barbados, and as he attempted to return home, died on Cumberland Island, Georgia, in the home of the daughter of a wartime friend, General Nathanael Greene.

His father's misfortunes made a profound impact on Robert E. Lee. He would worry that his own children would inherit their grandfather's lack of financial judgment and self-control, and through the years would write them long letters telling them how to behave. He would never name a son for his father, and rarely mentioned his name until the last decade of his life.

Although he only lived at Stratford for four years, he would remember it fondly all his life. On Christmas Day 1863, in the midst of war, Lee would write to his wife: "In the absence of a home, I wish I could purchase Stratford. That is the only place I could go to, now accessible to us, that would inspire me with feelings of pleasure and local love. You and the girls could remain there in quiet. It is a poor place, but we could make enough cornbread and bacon for our support, and the girls could weave us clothes. I wonder if it is for sale, and how much."

Robert E. Lee was born at Stratford Hall, the ancestral home of the Lees, on January 19, 1807. Set on a high bluff above the Potomac River, it is one of the great Colonial houses of America. The Great Hall, twenty-nine feet square with an inverted tray ceiling, seventeen feet high, is one of the most architecturally important rooms of the period. Before Robert was four, his father, "Light-Horse Harry" Lee, hero of the Revolutionary War, wasted the family fortune, lost Stratford Hall, and was in debtor's prison. All his life Robert E. Lee would dream of recovering Stratford Hall.

*R*obert lived with his mother, brothers and sisters in several Alexandria houses, from about 1810 until he left to begin his studies at West Point. Many relatives lived in the town, and life in Alexandria was a pleasant change for the family from the financial worries that hung over them at Stratford Hall. During the winter after the family arrived, a baby girl was born to Ann. There were now five Lee children, ranging from the newborn to a boy of thirteen.

For awhile, Robert went to live at Shirley Plantation and attend Eastern View, a school the Carters maintained there for their children. When he returned to Alexandria, his mother, now an invalid, was determined to instill in him her code of self-control, frugality and honor. Robert made her code his own and devoted countless hours to caring for her. By the time he was twelve he had shouldered the burden of managing the household and nursing his mother. He attended to the marketing, managed all the outdoor business, and took care of the family's horses. A relative told of Robert's taking his mother for carriage rides, attempting to entertain and amuse her, assuring her with the gravity of an old man that unless she was cheerful, the drive would not benefit her.

Robert was trying to decide what he would do with his life. He loved the soil, but he had no hope of owning enough land to become a planter. He thought he might be a doctor, but his mother could not afford to send him to medical school. His older brother Carter was at Harvard studying law, three other children were in school, and all were supported by Ann Lee's meager annual income of $1,200.

He decided he would attend the military academy at West Point. He was strong, in good health, and excelled at mathematics. Best of all, his education would cost the family nothing. The Lee family solicitor, William Fitzhugh, spoke to Secretary of War John C. Calhoun on Robert's behalf. An appointment was granted, but he would have to wait a year. A young Quaker named James Hallowell had opened a boys school in the house next door to the Lees, and he gave Robert personal instruction. This cost his mother $10 a term, a lot of money for a woman who was pinching pennies, but the investment would pay off at the military academy. Hallowell said Robert "imparted a finish and a neatness to everything he undertook."

When he left for West Point in 1825, his mother lamented: "How can I live without Robert? He is both son and daughter to me."

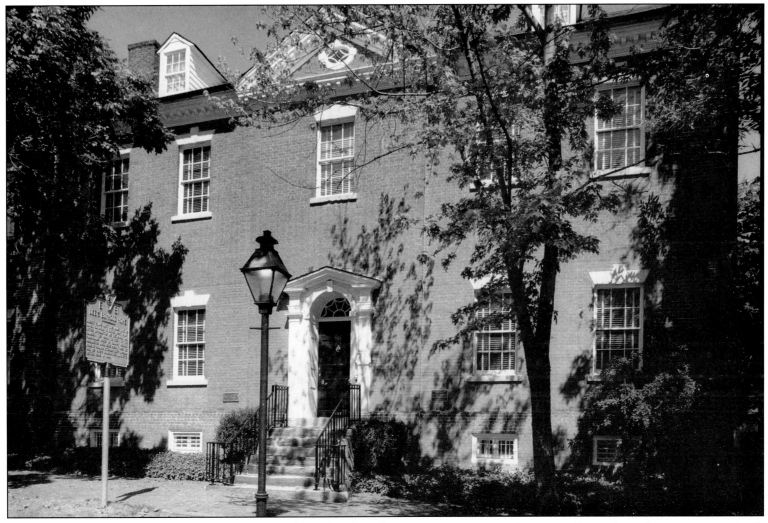

After Harry Lee lost Stratford, Ann and the children lived in this unpretentious townhouse in Alexandria, from 1811 to 1816 and again from 1820 to 1825, when Robert entered West Point. Robert went to school to study Latin, Greek and mathematics, for which he had natural aptitude. His oldest brother, Charles Carter Lee, was studying law at Harvard, and Sydney Smith Lee, the second son, was a midshipman in the Navy. His mother was now an invalid, his older sister suffered from a nervous disorder, and his younger sister was still a child. Robert was the man of the house.

Cadet Lee spent the summer drilling and learning the dos and don'ts of the military academy. He did well in his studies and at the end of the probationary period he was near the top of his class and had received no demerits. On the roll of general merit at the end of the year, he was given 295.25 out of a possible 300, and was named a "distinguished cadet."

In his second year he was appointed a staff sergeant and for the first time was responsible for the performance of others. On the basis of his excellent academic record, he was made a tutor to some of the slower members of his class. He went home on furlough in the summer and took his invalid mother to visit the homes of some of her Carter cousins. He was becoming a handsome, well-mannered, out-going young man.

Back at West Point, Lee became intrigued with "natural philosophy," as physics was then called. It concerned practical things, which always appealed to him, and was the basis of engineering. Nearly all ambitious cadets wanted to serve in the Engineer Corps. At mid-term he again stood second in his class.

In his senior year, Lee was appointed cadet adjutant, commander of the corps of cadets, West Point's highest honor. He made a concerted effort to graduate first in the Class of 1829, but finished a close second. He had not been given a single demerit during his four years at the academy. As an honor graduate he was allowed to choose the branch of the army in which he would serve and chose the prestigious Engineer Corps. The graduates were granted a two-month furlough and given the balance of their pay and allowances. Lee left West Point with $103.58.

In Lee's class were two other future Confederate generals, Joseph E. Johnston and Theophilus H. Holmes. In all, eleven of the cadets who were at West Point during Lee's four years would become general officers in the Confederacy, and one, Jefferson Davis, would be its president.

Lieutenant Lee was twenty-two, full grown at a height of five feet, eleven inches, and had brown eyes so dark they sometimes looked black. His wavy hair was black and abundant. His bearing was dignified, and his manners considerate and ingratiating. He was not yet a finished or accomplished officer, but he had received the best training his country could give. The rest would be up to him.

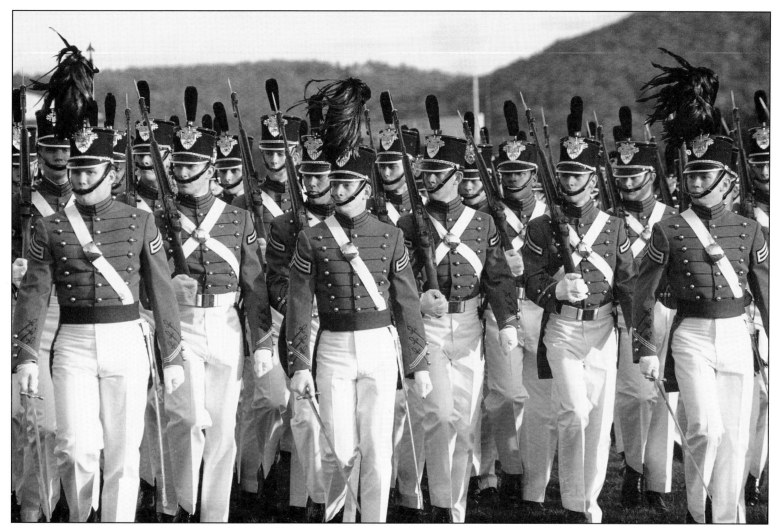

The corps of cadets parades on the plain at West Point. Lee graduated second in his class, having received no demerits during his four years. The corps was small in Lee's day. When he graduated in 1829, he was only the 542nd graduate of the academy, which was founded in 1802. Among Lee's fellow cadets were other future Confederate generals: Albert Sidney Johnston, Leonidas Polk, Jefferson Davis, Joseph E. Johnston, John B. Magruder, and William N. Pendleton. The future Confederate president, Jefferson Davis, a year behind Lee, stood twenty-second in a class of thirty-three.

*L*ieutenant Lee returned home to find his mother seriously ill. She was drained of vitality and seemed ready to die. He became her nurse, administering her medicines, sitting by her bed for hours on end. On July 10, 1829, he saw her faint breath fail her. Her death was a heavy blow. Forty years later he stood in that same room and recalled, "It seemed but yesterday that my beloved mother died."

For a time, Lee was in Georgetown helping to settle his mother's small estate. He became a regular visitor at Arlington, the mansion home of George Washington Parke Custis, the son of Martha Washington and the adopted son of George Washington. Custis brought his bride Mary Lee Fitzhugh here in 1806. Of their four children only one, Mary Anne Randolph Custis, survived infancy.

Mary, a distant cousin of Lee, was a frail blonde, aristocratic but not beautiful. Some described her as a spoiled, unpleasant young lady, accustomed to lavish parties and the constant attention of her father. Lee took pleasure in her company, perhaps because she resembled his mother in many ways. Both were somber and deeply religious.

The courtship was interrupted when Lee was ordered to report for duty at Cockspur Island near the mouth of the Savannah River. The mosquito-ridden island was desolate, and he worked all day in waist-deep mud, building dikes and a drainage canal for what became Fort Pulaski.

In his off hours, he wrote letters, sketched, played cards or chess, and showed a healthy interest in young women. Calling at the Savannah home of a West Point classmate, he regaled his friend's four sisters with lighthearted stories and flirtatious small talk. To one of the sisters he later confided: "I have not had the heart to go to Savannah since you left it."

The next summer he was home on furlough, courting Mary. Mr. Custis was not pleased with Lee's interest in his daughter. He had nothing against him personally, but he was aware of the financial tragedy of the Lees and knew that Robert had little to offer financially beyond his pay as a lieutenant.

Lee had a stroke of luck when he returned to Georgia. Design problems halted construction on the fort, and he was ordered to Virginia to work on the construction of Fort Monroe at Hampton Roads. At his first opportunity, Lee proposed to Mary. Mr. Custis reluctantly gave his consent, and they were married at Arlington on June 30, 1831. Robert had an affectionate pet name for Mary. He called her Mim.

The monumental Doric portico of Arlington, above, is visible from many parts of Washington. Lee once wrote that at Arlington House "My affections and attachments are more strongly placed than at any other place in the world." Lee and his wife, Mary, regarded it as their permanent home, and she and the children remained here while Lee was stationed at distant army posts. The house was built for George Washington Parke Custis, Martha Washington's grandson, whom Washington adopted. Custis turned the house into a virtual museum of Washington memorabilia.

*T*he newlyweds settled in at Fort Monroe. For Mary the humble quarters of a junior officer were a disappointing change from the splendor of Arlington and the excitement of Washington society. On September 16, 1832, Mary presented Robert with a son, whom they named George Washington Custis Lee after the baby's grandfather. The boy would be called Custis.

The marriage was soon visited by misfortune. After giving birth to a second child in 1835, Mary was struck by arthritis. Lee was stunned. Said a relative, "I never saw a man so changed and saddened."

Despite her painful disability, Mary bore Lee five more children. Lee adored the youngsters, describing them as "the dearest annuals of the season. I find something in every edition that I in vain look for elsewhere." His love for his children made even more painful his long absences from his family on tours of duty. Soldiering, he once complained, was a profession that "debars all hope of domestic enjoyment."

Homesickness for his family and his beloved Virginia was not the only frustration. His prewar army career involved a long series of routine assignments, which Lee often criticized in his letters home. After three years at Fort Monroe, he was transferred to the engineering department in Washington. As an assistant to General Charles Gratiot, though, Lee grew to dislike bureaucratic routine and petty army politics. Lee was considering resigning from the army, but instead volunteered for duty on the Mississippi River. In 1837 he left his family at Arlington for three years of service in St. Louis, using his engineering skills to help preserve the city from the unpredictable currents of the river. His family eventually moved to St. Louis, but they would return to Arlington for long periods.

Lee's life became more stable in 1841. Now a captain, he was assigned to Fort Hamilton on Long Island. For five years he labored at the tedious task of modernizing the aging fortification. In the early 1840s a national economic depression forced the army to reduce officers' salaries. Captain Lee's was cut by nearly half, forcing him to say: "I never was poorer in my life, and for the first time I have not been able to pay my debts."

Four years later, the outbreak of war with Mexico would abruptly change Lee's life.

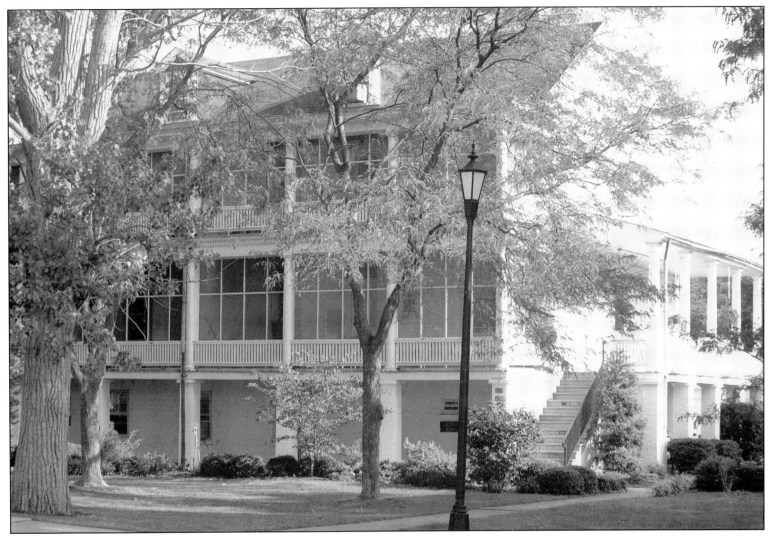

Lee, a lieutenant of engineers, was stationed at Fort Monroe, in Hampton, Virginia, from 1831 to 1834. He worked on the construction of the fort, known as the "Gibraltar of the Chesapeake." Lee and his wife were quartered in this building, and their first child, George Washington Custis Lee, named after his maternal grandfather, was born here in 1832. During the Civil War the fort was headquarters for Benjamin Butler and George McClellan. Lincoln and Grant both visited here, and Jefferson Davis was imprisoned in one of its casements, following his May 1865 capture.

*L*ee did not approve of the war. He wrote to Mary that America's incitement of hostilities with Mexico "disgraced" their country. Despite his misgivings, he distinguished himself as he experienced his first taste of battle. During the American bombardment of Veracruz, Captain Lee, although a staff officer, positioned and directed a battery that pummeled the stronghold and forced it to surrender. At Cerro Gordo, Lee guided a brigade behind the Mexican line, forcing the enemy to retreat. Near Mexico City, he helped outflank the foe by finding a path through a jagged lava field that was believed impenetrable.

Lee was thrice breveted and finished the war as a colonel. The American commander, General Winfield Scott, called Lee, a member of his staff and a fellow Virginian, "the very best soldier I ever saw in the field."

Officers who later would be enemies served together in Mexico. Captain Lee commended Lieutenant Grant in one of his reports. When Grant was officially thanked for his role in the attack on Mexico City, the thanks were conveyed to him by Lieutenant John Pemberton, who would surrender to Grant sixteen years later at Vicksburg. With Lee on Scott's staff were two bright lieutenants, Pierre G. T. Beauregard and George B. McClellan. James Longstreet and Winfield Scott Hancock fought together in the battle of Churubusco. At Gettysburg, Longstreet would command the attack against Hancock's corps at Cemetery Ridge. Albert Sidney Johnston and Joseph Hooker were comrades in arms at Monterey. Colonel Jefferson Davis's artillery officers in that battle, George H. Thomas and Braxton Bragg, would meet again at Chickamauga.

Shortly after the occupation of Mexico City, Scott's officers feted Lee at a grand banquet. At the close, Scott rose, rapped on the table, and offered a toast to "the health of Captain Robert E. Lee, without whose aid we should not now be here."

Scott's admiration for Lee never diminished. After the war, he remarked to Colonel Erasmus Keyes that "if hostilities should break out between our country and England, it would be cheap for the United States to insure Lee's life for $5,000,000 a year!" In 1854 he told an Ohio politician that Lee was "the best soldier in Christendom."

Lee, McClellan, Beauregard and other officers who fought in Mexico formed a long-lasting fraternity, the Aztec Club. They would see much of each other during the next thirteen years, and they would form the framework of most of the important army commands. In 1855, for example, the officers of the 2nd Cavalry included Lee, Albert Sidney Johnston, George Thomas, and Earl Van Dorn—Aztec Club members all.

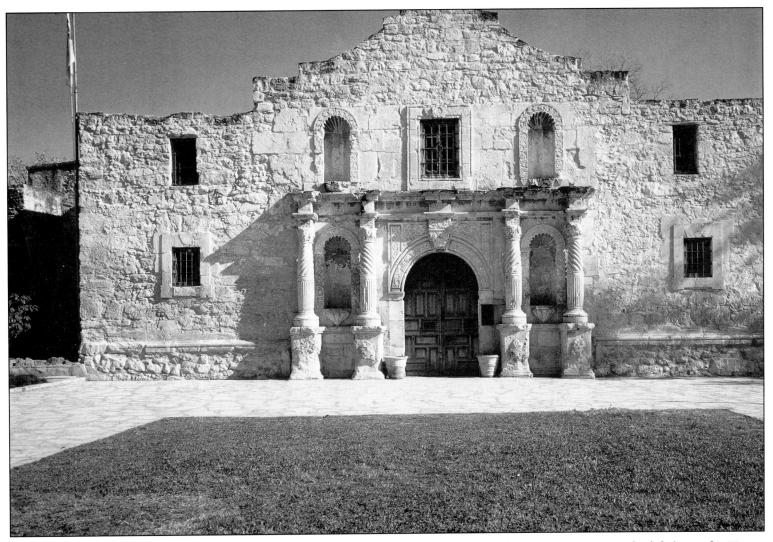

Captain Robert E. Lee made his reputation in the Mexican War, and the Alamo, where 185 Americans died fighting for Texas independence, is a fitting symbol of that war, for it was Texas statehood that triggered the war. Lee's daring reconnaissances behind enemy lines prepared the way for two American victories. Lee was commended and he, in turn, commended Lieutenant Ulysses S. Grant. P.G.T. Beauregard and George McClellan were both members of Winfield Scott's command staff; in fact, most senior Civil War generals first saw battle in places like Vera Cruz and Churubusco.

When Lee received orders in 1852 naming him Superintendent of West Point, he greeted the news "with much regret." He sought to avoid the appointment, claiming that the post required "more skill and more experience than I command." Once at West Point, though, he worked with tireless zeal. To the curriculum he added Spanish, English composition, military law, and military field instruction. He increased the course to five years, a move that barely outlasted his administration. He tightened discipline and raised academic standards. He was also instrumental in designing and introducing the plumed cadet full-dress hat, which is still in use today.

For all his accomplishments, he was best remembered by the cadets for his stately bearing. One wrote: "His unaffected natural dignity and grace of manner preserved a personal equilibrium which nothing could disturb." Apparently being superintendent gave him little satisfaction. After a year he admitted: "I have less heart for the work." Lee reported to the Secretary of War, who for most of his tenure was Jefferson Davis, who allowed him a wide latitude at the academy.

Lee and his family were together during his three years at West Point. Mary's mother died in 1853, and Lee, who had been close to his mother-in-law, took her death hard. Shortly after, Lee was confirmed into the Episcopal faith in Christ Church in Alexandria.

At West Point, Lee's hair began to turn gray, perhaps because he worried excessively about the cadets. His son Custis and a nephew, Fitzhugh Lee, were both in the corps of cadets, which seemed to deepen his sense of concern. Custis graduated first in his class in 1854, and Jeb Stuart, a particular favorite of Lee, was second. Other future generals included John B. Hood, Philip Sheridan, O.O. Howard, James B. McPherson, and John M. Schofield.

In 1855 Congress created several additional regiments, and Lee accepted the lieutenant colonelcy of the 2nd Cavalry. Even after his promotion in 1861 to full colonel of a line regiment, Lee struggled to keep his family on $4,000 a year.

The 2nd Cavalry was in Texas. Lee's family did not accompany him, and he was miserable. His letters took on an increasingly melancholy tone. A pain circulating down his arm suggested the onset of arterial disease. He seemed to be aging prematurely.

Lee was disappointed when his son Rooney failed to be admitted to West Point. He sent a letter admonishing the boy for thinking "entirely of his pleasures and not of what is proper to be done." Rooney went to Harvard but left without his degree, and took a commission in the infantry, which had been arranged by Lee's old friend, General Winfield Scott.

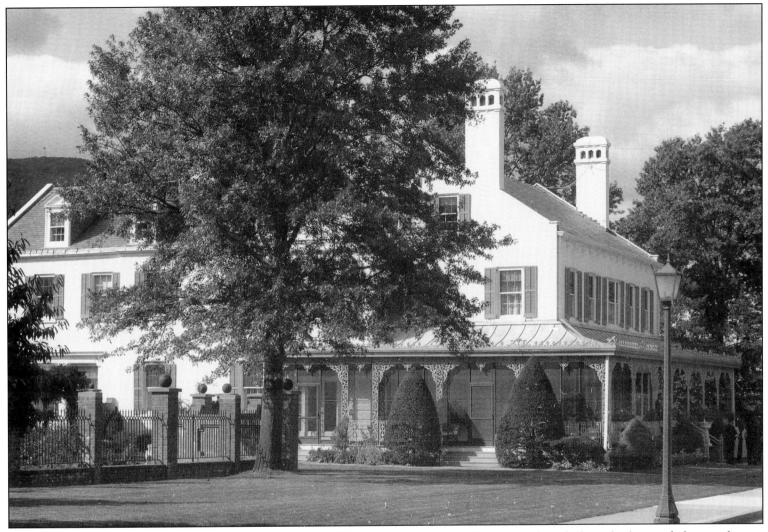

When Lee was appointed superintendent of the U.S. Military Academy in 1852, he tried to decline the honor, believing he didn't possess the necessary experience. His three years at West Point, however, demonstrated clearly that he could handle a large-scale operation and run it well. Among his cadets were seven future Civil War generals: his nephew Fitzhugh Lee, J.E.B. Stuart, Philip Sheridan, John B. Hood. O.O. Howard, James B. McPherson, and John M. Schofield. The Lees lived in the superintendent's house, above, their first real home since they had left Fort Hamilton in 1846.

*B*y the late 1850s, Lee was facing a crisis in his personal life. He considered himself a failure as a career officer. He told a friend that he must soon decide the question —"which I have staved off for twenty years"— of remaining in the army or returning to Virginia.

He scorned what seemed to be the only path to more rapid advancement: currying political favor. He was openly critical of his friend and fellow Virginian Joseph E. Johnston, who had been appointed quartermaster general by Secretary of War John Floyd, Johnston's cousin by marriage. Lee said the appointment epitomized "the system of favoritism."

Other promising officers had left the army. George McClellan was a railroad executive, earning three times as much as Lee. William Tecumseh Sherman was a banker in California. Ulysses S. Grant was a farmer in Missouri.

George Washington Parke Custis died in October 1857, and Lee took an extended leave to serve as executor of his father-in-law's estate. He had the opportunity to take over management of Arlington, but chose to stay in the army. He was still on leave when, in October 1859, Lieutenant Jeb Stuart arrived in Alexandria with orders for Lee to report immediately to the Secretary of War.

Lee was given a detachment of U. S. Marines and sent to Harpers Ferry where John Brown, the militant abolitionist, and his followers had attempted to seize weapons from the Federal armory there to arm the slaves for rebellion. People had been killed, and Brown and his followers had taken hostages and barricaded themselves in the armory firehouse.

When he arrived at Harpers Ferry that night, Lee wanted to attack at once but feared that in a night attack the hostages might be slain in the fighting. At dawn, he dispatched Stuart to demand Brown's surrender. When Brown refused, Lee sent a Marine storming party to batter down the door. In the scuffle, two raiders were killed and one Marine was killed and one wounded. It was all over in three minutes.

As usual, Lee was conscientious, protecting the captured abolitionists from mob violence. Here and in whatever service he rendered his countrymen, he was always kindly and courtly, with an almost saintly dedication to the right as he saw it. Lee made no bones about his strong sense of noblesse oblige. He once said: "There is a true glory and a true honor—the glory of duty done, the honor of the integrity of principle."

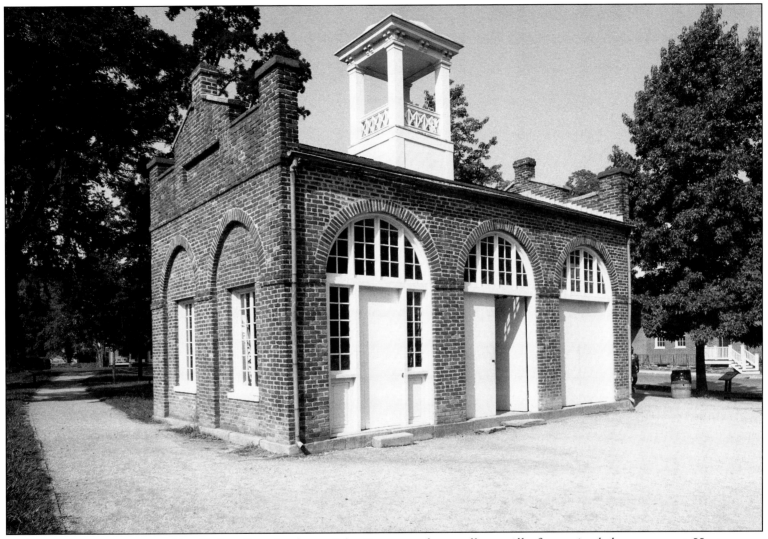

Believing he was summoned by God to free the slaves, John Brown and a small guerrilla force seized the armory at Harpers Ferry on October 16, 1859. After thirty-six hours, the band was overwhelmed by Marines led by Lee. Brown's raid, and the reaction to it by Northern abolitionists, stirred deep fears in the South. The movement by Southern states to secede was in part a reaction to Brown's incendiary message. The arsenal firehouse, above, where Brown was captured, now called John Brown's Fort, has been rebuilt and moved to a location on Arsenal Square near the original site.

*J*ohn Brown was indicted for treason and murder, tried and convicted. Within six weeks of his raid at Harpers Ferry he was hanged. The Governor of Virginia sent one of Brown's pikes to each of the other Southern governors who exhibited them in their capitols.

It became well known that Northern money had financed Brown, and this was enough to convince many Southerners that Yankee interests were plotting slave uprisings in the South, and that if the Republicans came to power they would send other John Browns to rouse the blacks to arson, rape and murder. In the North, many people thought it was barbarous to hang a crazy old man. Some even likened his execution to the Crucifixion.

Back on duty in Texas, Lee thought the collapse of the Union was inevitable. On February 1, Texas seceded, and delegates from the state were sent to Montgomery, Alabama to participate in the formation of the Confederacy. Orders reached Lee, who was acting commander of the 2nd Cavalry, at his headquarters north of San Antonio, relieving him of duty and ordering him to report to Washington. Before Lee could collect his belongings, San Antonio was in rebel hands.

As he journeyed toward Washington and home, he was fifty-four years old, robust, with strikingly handsome features set off by graying hair. He was well liked and respected by his friends, admired by his fellow officers, and was the favorite of General Winfield Scott, who considered him to be the army's finest officer.

Shortly after his return, General Scott offered Lee the second-in-command of the army. Scott later confided to a friend that he told Lee that "if you remain by the old flag... you will be placed in supreme command of the armies of the United States, subject only to a nominal command in myself..."

On April 18, the day Virginia seceded, Lee went to Blair House in Washington to meet with Lincoln's advisor, Francis Blair. Blair told Lee that a large army, perhaps 100,000 men, would soon be mobilized to suppress the rebellion, and that Lincoln and Scott both wanted Lee to command it. Lee refused, and went to talk to General Scott. He told the general he must not only decline, he must also resign from the army. As a loyal Virginian, he said, "I could take no part in an invasion of the Southern States. Save in defense of my native State, I never desire to draw my sword again."

"You have made the greatest mistake of your life," replied Scott sadly, "but I feared it would be so."

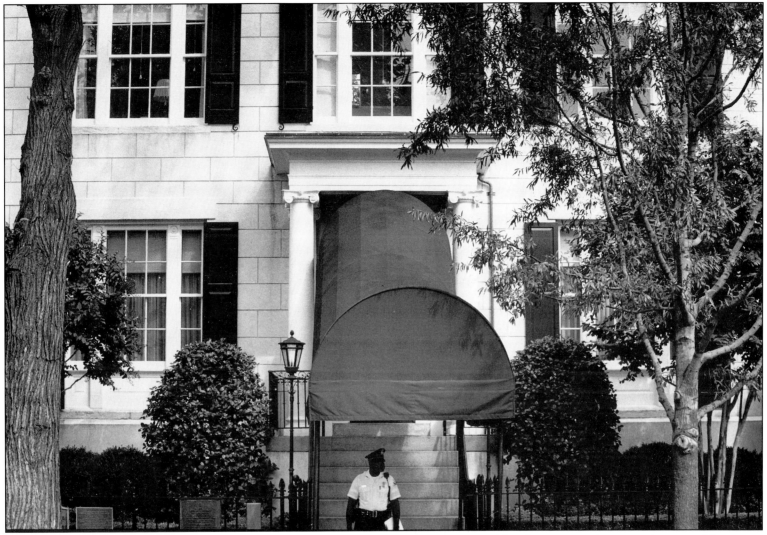

In this house, Francis Blair, advisor to Abraham Lincoln and later a major general, told Robert E. Lee that Lincoln wanted him to command the Union army. The offer was made at the urging of Winfield Scott, the aging Commander-in-Chief of the U.S. Army and Lee's commander in the Mexican War. Torn by conflicting loyalties to his country and to his state, Lee refused. The house was built in 1824 and purchased in 1836 by Francis Preston Blair, a friend of Andrew Jackson. Now owned by the government and known as the Blair-Lee House, it is used to accommodate visiting dignitaries.

Lee had a lot to think about on his ride back to Arlington. He had just turned down the opportunity to advance from colonel to general. He had abandoned his thirty-year career in the military, the only profession he had ever known. He held no brief for secession, and once had said "secession is nothing but revolution." He felt that the framers of the Constitution did not intend for the government "to be broken by every member of the Confederacy at will." He owned no slaves and did not approve of slavery, describing it in 1856 as "a moral and political evil...."

Other Southern officers, like General Scott, remained loyal to the Union. Some of them would play important roles in the war: Virginian George H. Thomas would save the Union army at Chickamauga and destroy the Confederate army at Nashville; North Carolinian John Gibbon would become a Union division commander while three of his brothers fought for the South.

It would work the other way as well. New Jersey's Samuel Cooper, whose wife was a Virginian, would become adjutant general in the Confederate army. Pennsylvanian John Pemberton, who also married a Virginian, would rise to command the Army of the Mississippi.

Five days after his meeting with General Scott, Lee was in the capitol at Richmond, accepting the appointment as commander in chief of Virginia's military forces. As he once told a friend, "I cannot raise my hand against my birthplace, my home, my children." He did not believe the road to independence would be an easy one. "I foresee," he said, "that the country will have to pass through a terrible ordeal, a necessary expiation perhaps for our national sins."

When the war was over, Lee would say, "I did only what my duty demanded. I could have taken no other course without dishonor. And if it all were to be done over again, I should act in precisely the same manner."

When Virginia seceded on April 17, 1861, she brought critical resources to the Confederacy. Her population was the largest in the South. Her industrial capacity was nearly as great as the seven original Confederate states combined. The Tredegar Iron Works in Richmond was the only plant in the South capable of manufacturing heavy ordnance. Her prestige was expected to attract the rest of the upper South to the Confederacy. But the greatest asset Virginia brought to the cause of Southern independence was Robert E. Lee.

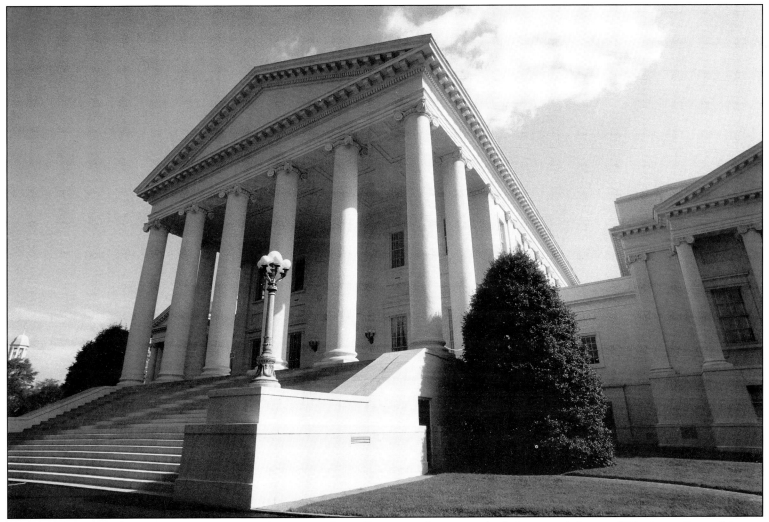

On April 22, 1861, in the State Capitol, above, Lee formally accepted command of the armed forces of Virginia. From May 1861 until the end, this building also was the capitol of Virginia. Lee would come to the capitol many times during the next four years to confer with Jefferson Davis, whose offices were here. The building was designed by Thomas Jefferson, with the help of Charles Louis Clerisseau, whom he had met in France. Jefferson wanted the capitol to represent Virginia's break with British authority and culture, as symbolized by the brick buildings of Williamsburg.

*J*efferson Davis had other plans for Lee. Davis, a West Point graduate, a hero in the Mexican War, and a former Secretary of War, had placed the troops from all the Confederate states under his personal command. He gave Lee the task of organizing the Southern forces, an administrative assignment that would last for a year. For awhile, he was assigned to oversee the ill-fated campaign in western Virginia. Richmond newspapers, blaming him for the reverses there, mocked him as "Granny Lee" and "Evacuating Lee." He was sent to South Carolina in November 1861 to report on the coastal defenses there. Recalled to Richmond four months later, he resumed his duties as an advisor to Davis. Lee was not at First Manassas, the first major Confederate victory. He told his wife it was "a glorious victory," but added that he was "mortified at my absence."

Things were about to change. General George McClellan began landing his army on the Peninsula southeast of Richmond. By April 2, he had 58,000 men at Fort Monroe, and was preparing to move against the Confederate capital.

First McClellan captured Yorktown and Williamsburg and, by May 15, his army, now numbering 120,000 troops, was only six miles from Richmond. There McClellan hesitated. Believing he was outnumbered, he repeatedly asked Washington for the 56,000 troops under Generals Irwin McDowell and Nathaniel Banks who, at Lincoln's insistence, were guarding Washington.

Joseph E. Johnston struck at McClellan on May 31 in the inconclusive Battle of Seven Pines (called Fair Oaks in the North). One of the 11,000 casualties was Johnston himself, who took a bullet in the shoulder and a shell fragment in the chest. On June 1, Davis gave command of the army to Lee.

Within three months, Lee would fashion a smoothly functioning army out of the most eccentric, touchy, individualistic group of generals ever assembled—impetuous A.P. Hill, ponderous James Longstreet, flamboyant Jeb Stuart, sickly Richard Ewell, sharp-tongued D.H. Hill, and Stonewall Jackson, who resembled an Old Testament prophet, but possessed a military genius all his own. Soon, Lee would be well on his way to becoming the greatest soldier of the war.

Before the war Lee was a frequent visitor at Berkeley Hundred, a plantation on the north bank of the James River, the home of the Harrisons, the prominent Virginia family that included two presidents—William Henry Harrison and Benjamin Harrison. During part of the 1862 Peninsula Campaign, it was used as the headquarters of General McClellan. President Abraham Lincoln visited the plantation twice to confer with McClellan and review the 140,000 troops encamped in the fields nearby. During the Union retreat in the midst of the Seven Days battles, Berkeley was a field hospital.

*I*f McClellan's army was not reinforced, Lee believed he could throw it back from the gates of Richmond. Should McDowell and Banks armies move south and attack the capital, it would be as good as lost. Lee gave Stonewall Jackson, operating independently in the Shenandoah Valley, the task of creating a diversion that would keep those armies occupied. Jackson proceeded to conduct as remarkable a campaign as the war would produce.

Jackson, a West Pointer and a former professor at the Virginia Military Institute in Lexington, was "a particularly seedy, sleepy-looking old fellow, whose uniform and cap were very dirty." But he was perfectly suited for an independent command. He kept his own counsel, and marched his men so hard that they called themselves "Jackson's foot cavalry." One of his soldiers said, "All Old Jackson gave us was a musket, a hundred rounds, and a gum blanket, and he druv us like hell."

The Valley was vital to the Confederacy. It was a source of food and forage, but more important it was a military highway, a great "covered way" for Confederate forces. Shielded on the east by the Blue Ridge Mountains, whose gaps were easily screened from prying eyes by cavalry, a rebel army could march straight down the Valley toward the northern heartland. But a Union army marching up the Valley would be headed away from Richmond.

Jackson started off by attacking a vastly superior Federal force at Kernstown. He was defeated but he accomplished what he had set out to do. Unwilling to believe that Jackson had only 4,200 troops, Washington braced for a Confederate invasion of the North. McDowell and Banks were kept near Washington, and a full division was detached from McClellan to protect the Shenandoah Valley.

With Ewell's division bringing his strength up to 17,000 men, Jackson withdrew up the valley, then swung west to rout a Union force at McDowell. Moving north again, he destroyed the garrison at Front Royal, defeated Banks at Winchester, and chased him to the Potomac.

Lincoln, now thoroughly alarmed, hoped to trap Jackson between the converging columns of Generals Fremont and Shields, whose forces totaled 50,000. Although his little army was traveling with a seven-mile long column of wagons laden with booty, Jackson managed to slip between the columns, whipping Fremont at Cross Keys and Shields at Port Republic. He then joined Lee near Richmond in late June. "God has been our shield," Jackson said.

A statue of Thomas "Stonewall" Jackson, by Moses Ezekiel, the general's blouse blown by an imaginary breeze, overlooks the parade ground at the Virginia Military Institute, in Lexington, where he taught artillery tactics in the 1850s. Jackson, who used the cannons beside the statue in his instruction, named them Matthew, Mark, Luke and John. Students thought him strange and nicknamed him Tom Fool. His troops thought he was strange, too, but they loved him and would follow him to hell and back. Jackson was the Confederacy's first great hero and, next to Lee, its most revered commander.

A month passed before Lee was ready. He strengthened the defenses of Richmond, prepared for reinforcements from Georgia and the Carolinas, and arranged to bring Jackson's forces from the Shenandoah Valley. To keep McClellan off balance, he sent General J.E.B. Stuart, now his cavalry commander, on an audacious reconnaissance raid that took him completely around the Union army. Jeb Stuart was a dashing cavalryman who dressed the part. He affected a full dark beard, a plume for his hat, and a magnificent gray uniform with a flowing cape. He was a hero to young men and an idol to young women.

After doing considerable damage in the rear of the Union lines, Stuart crossed the James and eluded pursuing Union cavalry. He told Lee that McClellan was in a dangerous position astride the Chickahominy River. Launching the series of battles called the *Seven Days*, Lee attacked on June 26, rolling up the Union right at Mechanicsville, then suffered heavy losses attacking the strong Union positions at Beaver Creek.

In a week of almost continuous fighting, Lee attacked at Gaines' Mill, Savage's Station, Glendale (also called Frayser's Farm), and finally at Malvern Hill, where a stiff Union resistance halted Confederate pursuit.

In spite of heavy losses and varying success, Lee pressed the attack, time and again. At Malvern Hill, Lee sent an attack across an open field against strong defenses and suffered appalling losses. He wanted to destroy "those people," his term for Union forces, and underestimated their strength.

The next day McClellan circled east of Richmond to the security of navy gunboats on the James at Harrison's Landing to rest and refit his mangled army. Lee fell back to Richmond for the same purpose. The Seven Days ended with 35,000 Union and Confederate casualties. A young Georgia soldier wrote home: "I have seen, heard and felt many things in the last week that I never want to see, hear nor feel again."

The Seven Days taught Lee to be a great general. He learned the enormous advantage of holding the initiative, of forcing the enemy to march to his drum. In fighting McClellan for Richmond, Lee took the offensive tactically as well as strategically. His strategy was excellent, but his tactics reflected his inexperience. His battle plans were too complicated, his staff work was poor, his orders too demanding. But his flawed offensive was relentless, and McClellan gave way before it.

Lee was also winning the loyalty of his lieutenants. Jackson wrote in a May 1862 letter: "Lee is the only man I know whom I would follow blindfolded."

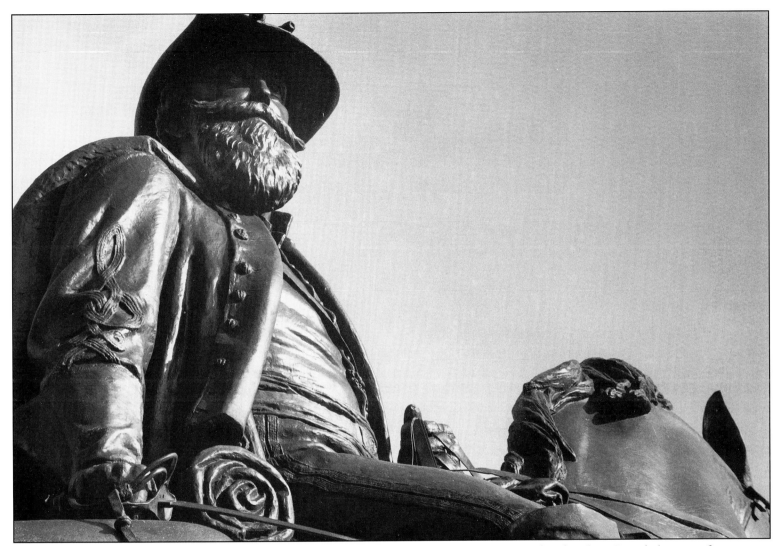

James Ewell Brown—Jeb—Stuart was the dashing, flamboyant commander of Lee's cavalry, his "eyes," and the most famous cavalryman of the war. Like Lee, Stonewall Jackson, and Jefferson Davis, his statue graces Monument Avenue in Richmond. Twice he led his troopers around McClellan's army, in the Peninsula campaign and after Antietam. Stuart was mortally wounded in the Battle of Yellow Tavern, near Richmond, on May 11, 1864, at the age of thirty-one. His death was a severe blow to Confederate morale. Lee could only say, "I can scarcely think of him without weeping."

President Davis was criticized for choosing Lee to command the army defending Richmond. Joseph E. Johnston was a hero, and many believed that the shell that had wounded him had dealt the Confederacy an almost irreparable injury. The Richmond *Examiner* called Lee "a general who has never fought a battle... and whose extreme tenderness of blood inclined him to depend exclusively on the resources of strategy." Some of Lee's new subordinates confided that they were now being led by a staff officer without the "power and skill for field service."

George McClellan, commander of the Federal troops pressing Richmond, did not think much of Lee. He had known both Lee and Johnston during the Mexican War, and he was delighted at the change in command. "I prefer Lee to Johnston," he wrote. "The former is too cautious and weak under grave responsibility—personally brave and energetic to a fault, he yet is wanting in moral firmness when pressed by heavy responsibility and likely to be too timid and irresolute in action."

It was to Davis's credit that he chose Lee; to Lee's credit that he was able to get along with Davis. Davis originally named five men to the rank of full general—Samuel Cooper, Albert Sidney Johnston, Robert E. Lee, Joseph E. Johnston and Pierre G. T. Beauregard. Cooper was a desk general, and A. S. Johnston, Davis's close friend and personal favorite, was mortally wounded at Shiloh in April 1862. Davis quarreled with Joseph Johnston and Beauregard throughout the war, transferring them from high command to minor assignments and back again as his temper dictated. Other generals would have problems with Davis—Braxton Bragg and John Bell Hood both incurred the displeasure of the President and suffered the consequences.

Amazingly, Lee and Davis apparently never quarreled. Davis was mercurial, given to periods of profound gloom, testy, impatient, arbitrary. He was a proud man and sensitive of his honor. He could never forget a slight or forgive the man who committed it. Moreover, Davis, a West Pointer, a hero of the Mexican War, and a former Secretary of War, liked to make major military decisions himself.

Perhaps Lee's legendary self control kept him from confrontations with Davis, or perhaps he was just too much of a gentleman to quarrel with the President. Not that Lee didn't have a temper. When anger broke through his facade of studied calm, his neck turned red and his head jerked spasmodically, and those who had experienced his rage quickly departed the scene. Once he told an aide, "When I lose my temper, don't let it make you angry."

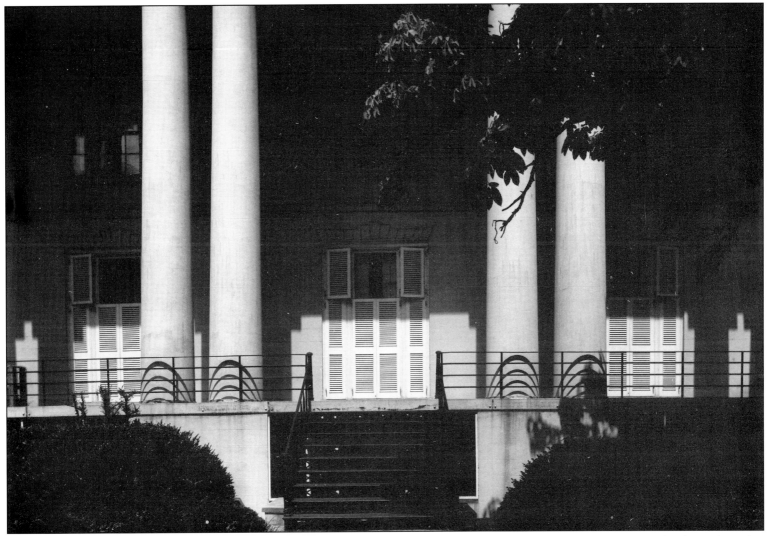

This Greek Revival mansion, atop Shockoe Hill in Richmond, was designed by Robert Mills for Dr. John Brockenbrough and completed in 1818. It was leased by the Confederate government for the use of President and Mrs. Davis, and they lived here throughout the war. After the Davises moved in during August 1861, levees were usually held here every fortnight. Davis would generally pass through the parlors, extending his hand to each guest and saying, "I am glad to meet you here tonight." Anyone was welcome. Shortly after Richmond fell Lincoln came here and sat for awhile at Davis's desk.

*T*he South had found a new hero. Everyone was talking about the brilliant repulse of McClellan's army. Lee said that the "God of Battles" just might be marching with the Confederacy. He "had seen His hand in all the events of the war. Oh, if our people would only recognize it and cease from their vain self boasting and adulation, how strong would my belief be in the final success and happiness to our country."

Lee now turned his attention to another Yankee general, John Pope, who commanded the remnants of Banks' army in upper Virginia. Lee believed Pope would come south to aid McClellan, and wanted to hit him first. He told Jackson to take half the army, go to central Virginia, find Pope and destroy him. Marching sixty miles in two days, Jackson caught up with Pope at Cedar Mountain. The battle seesawed for awhile, but Jackson himself led the deciding charge. Pope limped north toward Washington.

Leaving a small force to watch McClellan, Lee took the rest of his army and joined Jackson. Lee devised a risky dangerous plan to encircle Pope. Jackson slipped around Pope's right, burned his supply base, then dug in near the old Manassas battlefield. Pope attacked him there again and again, but was beaten back each time. Rallying for a final effort, the bluecoats drove forward only to be hit on the right flank by Longstreet, whose troops had reached the battlefield undetected. The battle was a Union disaster: 15,848 casualties to 9,789 for the Confederates.

Second Manassas was a strategic masterpiece. It demonstrated Lee's unerring sense of the third dimension in warfare—time. With two armies to worry about, he broke Pope's army just hours before McClellan's could come to the rescue. A staff doctor wrote that Pope "had been kicked, cuffed, hustled about, knocked down, run over, and trodden upon as rarely happens in the history of war." Lee wrote President Davis: "This Army today achieved on the plains of Manassas a signal victory."

In less than three months Lee had practically cleared Virginia of enemy troops. In the process Jackson and Longstreet learned to trust him and work with him. They became extensions of Lee, responding instinctively to his needs. The Army of Northern Virginia now perfectly fulfilled Jackson's own maxim: "Always mystify, mislead, and surprise the enemy if possible."

As Robert Frost put it, "[Lee's] dispositions for battle were beautiful. His two great divisions under Longstreet and Jackson were like pistols in his two hands, so perfectly could he handle them."

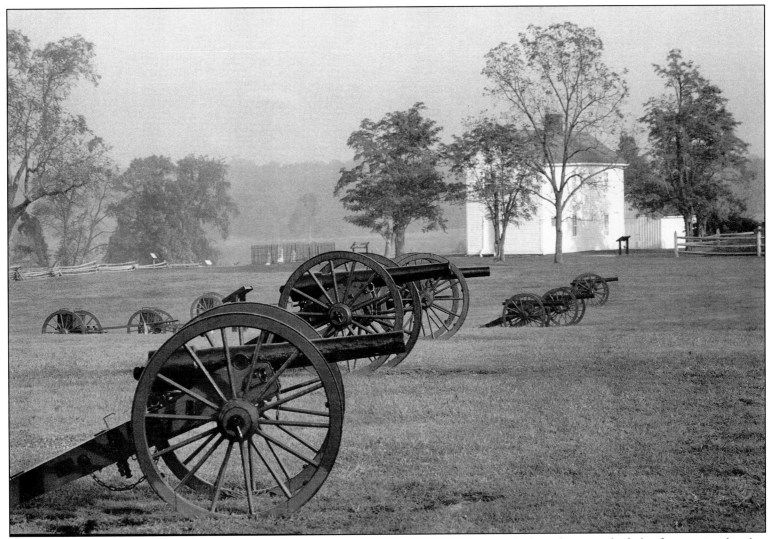

Expecting to see the Confederate army vanquished, politicians and their guests picnicked as they watched the first major battle of the war, at Manassas, southwest of Washington. The seesaw battle was resolved in the fighting at Henry Hill, where "Stonewall" Jackson earned his sobriquet. Rebel reinforcements arrived by train from the Shenandoah Valley in time to turn the tide. Lee did not participate in the battle, but a year later he decisively defeated General John Pope here. Pope made his headquarters at the Stone House, above, which served as a field hospital in both battles.

*A*rlington, which Lee loved so dearly, would be lost to him forever. He left the house on April 22, 1861. Mrs. Lee remained behind and began packing family possessions and moving them to places of safety. Lee urged her almost daily to leave, but she stayed until Custis resigned his U.S. Army commission in mid-May. A week later, Federal troops crossed the Potomac and occupied northern Virginia and the Arlington estate.

The Union army kept Arlington for the duration of the war. General McClellan used it as his headquarters and drilled troops on the grounds. The great stands of oaks, elms and chestnuts were cut down to build fortifications and to supply firewood. Visiting in July 1862, Markie Williams, a cousin of the Lees, noted the "poor house looked so desolate" and "strangely distorted."

In the early years of the war, sympathetic Union officers, especially those who had served with Lee, attempted to preserve the house and grounds. But these constraints yielded to trenches, rifle pits, and earthwork forts, which were built as part of the defenses of Washington. Military roads crisscrossed the fields and hillsides of Arlington. The estate was seized for non-payment of taxes in 1864. On behalf of the Lees, a cousin, Philip R. Fendall, tried to pay the taxes and penalties, but the commissioners refused to take the money. Thus the estate was confiscated under the guise of a tax sale. The man responsible was Montgomery Meigs, the Quartermaster General of the Union. A Georgian, Meigs had developed an intense hatred for all Southerners who fought against the Union he still served. He particularly detested Lee, under whom he had served in the peacetime army.

By the spring of 1864, the Union dead had completely filled the military cemeteries of Washington and Alexandria. Secretary of War Stanton ordered Meigs to choose a new site, and he chose Lee's lawn for the new army cemetery. He ordered that the Union dead be laid to rest within a few feet of the front door of the man he blamed for their deaths. He wanted to make sure that no one could ever again live in the house.

Meigs was furious to learn that his orders had been disobeyed: The first bodies had been buried out of sight, in a distant corner of the estate once reserved for the burial of slaves. Meigs immediately ordered that twenty-six Union coffins be brought to Arlington and watched as they were lowered in a ring around Mrs. Lee's old rose garden. He ordered a Tomb of the Unknown Dead be built in the center of the garden. A few months later, Meigs' son, a Union lieutenant killed in the Shenandoah Campaign, was buried in the lawn of his father's old commander.

Lee's enemies were buried in what was once his front yard. Ironically, that yard would become Arlington National Cemetery, the nation's most hallowed ground.

Arlington House, designed by George Hadfield, who designed the Capitol, and once the home of the Lee family, hovers over Washington like an apparition from the past. A month after Lee chose to serve with the Confederacy, his wife and family left the property, just ahead of the Union army. When Mary Lee, who suffered from arthritis, failed to appear in person to pay taxes, the 1,100 acre estate was confiscated by the government. So that Lee could never live here again, a portion of the estate was set aside for the cemetery that would later become the nation's best-known burial ground.

*L*ee did not rest after the Battle of Second Manassas. He knew he couldn't capture Washington, it was too strongly fortified, and McClellan's troops had returned from the Peninsula. Instead, Lee convinced President Davis to let him invade the North. His plan had much to recommend it. He hoped to find both men and supplies among Confederate sympathizers in Maryland. Moreover, a victory on Northern soil might persuade Great Britain and France to recognize the Confederacy, and would strengthen the Peace Party, the Northern political movement to end the war.

The Army of Northern Virginia, 55,000 strong, crossed the Potomac, entered Maryland, and headed for Harrisburg. With that section of Pennsylvania in Lee's possession, Maryland and Washington would be cut off from the North. But Lee found no cattle, no grain or vegetables, and no young men waiting to join the Confederate army. The tattered and dirty rebels did not inspire confidence, and their Confederate dollars were worthless.

To feed his army Lee needed a supply line to the Shenandoah Valley. To open one, Lee sent Jackson and half the army to knock out the Federal garrison at Harpers Ferry, at the head of the valley. The rest of the army proceeded toward Pennsylvania. Philadelphia panicked when it learned Lee was north of the Potomac, and the governor called for 30,000 volunteers to fight the invaders.

McClellan, moving to intercept Lee, did not know where the Confederate army was headed—to Philadelphia or New York or westward to cut the Union in two. Then McClellan got lucky. Lee had prepared a complete plan of his campaign, Special Order 191, with a copy for each of his commanders. A careless courier lost a copy. It was found and brought to McClellan, who told his staff, "Here is a paper with which, if I cannot whip Bobbie Lee, I will be willing to go home."

Lee marched westward to South Mountain, but without Jackson he could only delay the Union troops coming through the mountain gaps. Learning that McClellan had his battle plans, Lee considered returning to Virginia but decided to fight it out, confident that he could again out-general McClellan.

By the afternoon of September 15, the armies were on opposite sides of Antietam Creek, in the rolling Maryland farm country near the little town of Sharpsburg. McClellan, ever timid, did not seize the opportunity to strike Lee while Jackson was away. While he hesitated, Harpers Ferry surrendered, allowing Jackson to reach Sharpsburg before the fighting began.

The next day, September 17, 1862, would be the bloodiest day of the war.

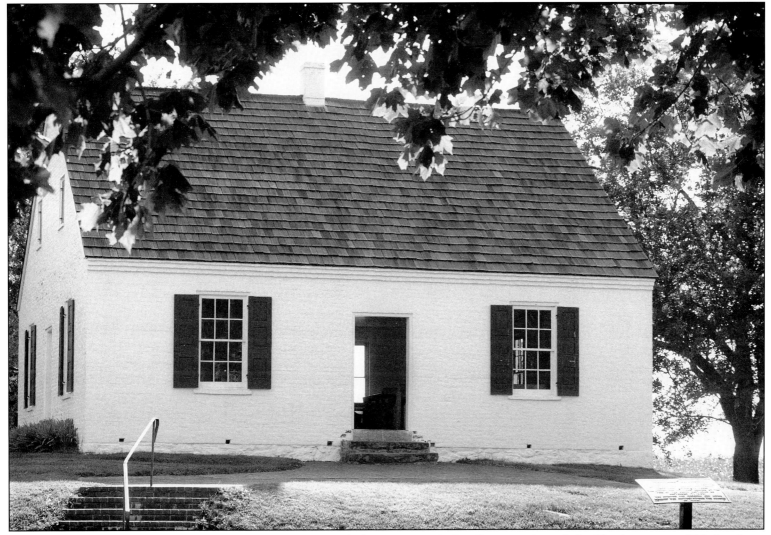

Lee's luck seemed to leave him as soon as his army crossed the Potomac. In his first invasion of the North, a copy of his battle plan fell into the hands of George McClellan, who boasted: "Here is a paper with which if I cannot whip Bobbie Lee, I will be willing to go home." The battle was the bloodiest day of the war: some 23,000 men were killed or wounded. McClellan couldn't deliver: Lee escaped defeat, and retreated to Virginia. McClellan didn't pursue the rebel army, and an irate Lincoln dismissed him from command. The Dunker Church, above, was the scene of heavy fighting.

At dawn on September 17, 1862, Hooker's artillery began a murderous fire on Jackson's troops, who were advancing through a cornfield near the tiny Dunker Church. Hooker reported that "every stalk of corn... was cut as closely as could have been done with a knife, and the slain lay in rows precisely as they had stood in their ranks a moment before." The bluecoats surged forward, driving the rebels before them.

Jackson was reinforced, and drove the Federals back. Attempting to extricate some isolated Union troops near the church, Sedgwick's division advanced into the West Woods, where rebel troops were waiting. They struck him on both sides, and inflicted heavy casualties. Another Federal division veered south into D.H. Hill's troops, who were dug in along an old sunken road, now known as Bloody Lane. The fighting there raged for nearly four hours.

General Ambrose Burnside had been trying all morning to get his troops across a stone bridge over Antietam Creek, but 400 Georgia sharpshooters kept them pinned down. At one in the afternoon, Burnside finally forced a crossing, then spent two hours forming his troops before going into action. By late afternoon, though, he was threatening to cut off the line of retreat for Lee's embattled army.

General A.P. Hill saved the day. Left behind at Harpers Ferry, he heard the guns and force-marched his division to Sharpsburg, arriving about four o'clock. Immediately going into battle, Hill's troops drove Burnside back almost to the stone bridge. McClellan, with 25,000 troops in reserve, could not bring himself to make a final all-out attack.

The long day was over. A rebel remembered that, "The sun seemed almost to go backwards, and it appeared as if night would never come." About 23,500 had fallen, nearly one in four of the combatants, and the blasted landscape smoldered and smoked, filled with the pitiful cries of wounded men.

By the next morning sufficient Union reinforcements arrived to cover McClellan's battle losses. For Lee there were no reinforcements. Lee audaciously remained in position the next day, inviting attack, but McClellan didn't take the challenge. That night Lee withdrew and headed toward Virginia, his invasion at an end. McClellan was content to let him go, a decision that would soon cost him the command of the Army of the Potomac.

Five days later, Lincoln issued the Emancipation Proclamation, declaring that all slaves in states still in rebellion were free. It freed no slaves, but it was a political masterstroke. It made slavery an issue in the war, and neither Britain nor France would now consider coming to the aid of the Confederacy.

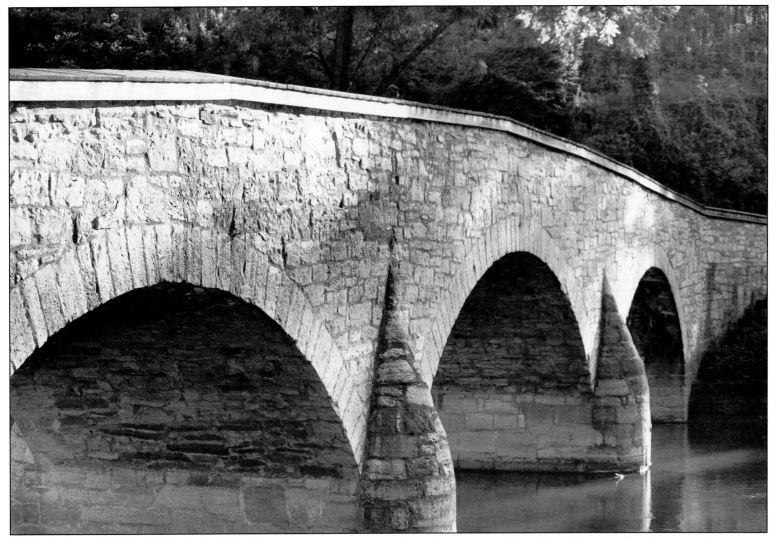

While the Battle of Antietam raged less than a mile away, General Ambrose Burnside stubbornly spent four hours trying to get his troops across this bridge in the face of fire from Georgia sharpshooters. Ironically, the creek could be forded in several places nearby. When Burnside finally got his men across, he wasted more time getting them into formation. This delay enabled A.P. Hill to quickmarch his division from Harpers Ferry and throw them into the battle just as Lee's outnumbered army was about to be swamped. The bridge is now known as the "Burnside Bridge."

*A*ntietam marked a change in Lee. Before then, he had believed that his chief duty was to bring his troops into position on the field of battle. He would then leave tactical details of action to the brigade and division commanders. But at Sharpsburg, when every general was occupied in his own part of the battle, the tactical decisions had fallen on Lee, and he had made them flawlessly. He now no longer need worry that he was less a tactician than a strategist.

Lee needed time to reorganize and refit his army, and McClellan accommodated him. Lee divided his army into two corps, one under Longstreet and the other under Jackson. Most of the divisions had five weeks to recuperate in the hills around Culpeper. Food was plentiful, and most of the soldiers received new uniforms and blankets. News of the Emancipation Proclamation reinforced the belief that the election of Lincoln was a conspiracy against the Constitution, and a renewed sense of justification stiffened the Confederacy.

Meanwhile, tragedy struck the Lee family. Annie, the Lee's second daughter, fell ill and died while visiting friends in North Carolina. Lee wept when he learned of her death. "I cannot express the anguish I feel at the death of my sweet Annie," he wrote to his wife.

The people of the North were demanding action. Why was Lee allowed to escape? Why doesn't the Army of the Potomac march on Richmond? In response, Lincoln replaced McClellan with General Ambrose E. Burnside, who had successfully conducted an independent operation in North Carolina earlier in the year. "I fear they may continue to make these changes till they find someone whom I don't understand," Lee said, hearing the news.

The Army of the Potomac was near Warrenton, east of the Blue Ridge. Burnside planned to make a simple, straightforward move on Fredericksburg, then continue due south to Richmond. Success would depend upon getting the Union army across the Rappahannock and seizing the heights behind the city before Lee arrived.

Logistics sabotaged Burnside. The first Union troops arrived at Fredericksburg on time, but the pontoon bridging equipment arrived late. The river was fordable in places, but could rise with little warning. Not wanting to risk having part of his army stranded across the river, Burnside decided to wait. While he waited, Lee arrived.

Before accepting command of the Army of the Potomac, Burnside said that he did not consider himself fit for high command. He would soon prove that he was a good judge of character.

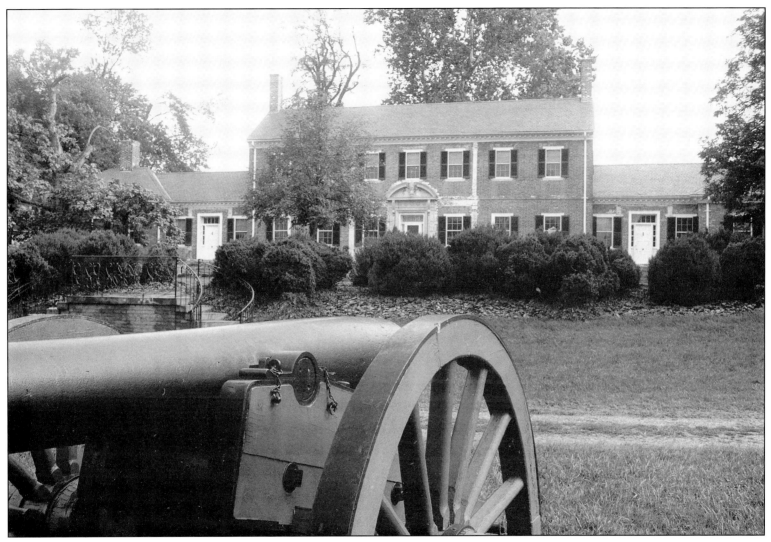

Legend has it that Lee and his future bride first met at a house party in this Georgian mansion, now known as Chatham, on Stafford Heights, across the river from Fredericksburg. It was built in the 1770s for William Fitzhugh, a wealthy landowner. In the war it was the headquarters for Union Generals Joseph Hooker and Edwin V. Sumner, and a field hospital where hundreds of Union soldiers were cared for by medical personnel and volunteers like Clara Barton and Walt Whitman. Fredericksburg, the scene of four major battles, changed hands seven times during the war.

Lee waited south of the Rapidan, with one brigade in Fredericksburg and the rest of his army on the edge of a plateau running parallel to the river. Longstreet held the left; Jackson the right. The left rested on a steep elevation known as Marye's Heights. To reach this position, the Federals would have to cross a wide canal and a sunken road which lay behind a stone wall at the base of the hill.

On December 11 the Union army, 120,000 strong, began building four pontoon bridges across the river. Despite vicious fire from Confederate sharpshooters, most of the Union army had crossed the river by noon of the next day and were preparing to attack.

Two days later, Burnside changed his plans. Instead of attacking with his whole force, he sent one division forward. Heavy fog hid the attackers. When it lifted, John Pelham, a young artillery major, swung into action. With only two guns, he and his men galloped in front of the lines and began firing. They delayed the attack until their ammunition was gone, then galloped to safety.

The advance was halted again, this time by Jackson's artillery. Then Union guns began firing, and an artillery duel raged for ninety minutes. Jackson's guns were silenced, and the bluecoats surged forward and found a weak spot in the line. Then Jubal Early and A.P. Hill recaptured the position.

In the most senseless assault of the war, Federal troops attempted to take Marye's Heights an incredible fourteen times, suffering terrible losses. Longstreet said as long as his ammunition held out and they kept coming, he would kill Yankee soldiers until there were none left in the North. Watching the slaughter, Lee said, "It is well that war is so terrible or we should grow too fond of it." Two nights later, the Union army retreated across the river.

Lee at Fredericksburg, some historians say, could have destroyed the Army of the Potomac. When the fighting ended, it was dejected and disorganized, and a strong counterattack could have swept the Union's major piece off the board. Ironically, Lee had captured a copy of Burnside's attack order for the following day, and had decided to delay his attack until after that assault had been repulsed. The attack was called off, the Federals had dug in; the opportunity was gone.

It was a resounding victory, nonetheless. Confederate losses were 5,300 killed and wounded, while Union losses were more than twice as great, 12,600 men. Five months later, the Union army would be commanded by "Fighting Joe" Hooker, whom Lee sarcastically referred to as "Mr. F. J. Hooker." Lee again would take cruel advantage of an opponent who was commanding an army in battle for the first time.

At Fredericksburg, in late 1862, Lee gave Ambrose Burnside a painful lesson in generalship. Burnside launched an ill-considered attack at the heart of Lee's defenses on Marye's Heights. Artillery on the heights and infantry firing from behind a stone wall slaughtered Federal soldiers in large numbers. As Lee watched the battle, he remarked, "It is well that war is so terrible, or we should grow too fond of it." This monument honors Sergeant Richard Kirkland, who was so moved by the cries of the Union wounded lying on the battlefield that he went among them to give them water.

Chancellorsville was Lee's crowning achievement, a battle in which he defeated an army nearly twice the size of his. It also was an example of leadership under adversity, and the most daring of the Lee-Jackson maneuvers. And, tragically, it was the last time the two warriors would go into battle together.

Four months had passed since the Battle of Fredericksburg. The Army of the Potomac now numbered 134,000 men, organized into seven corps. Hooker, now in command, divided his army into two attack groups, hoping to catch Lee's 60,000-man army in a pincer movement. On April 25, 1863, three Union corps crossed the Rappahannock and the Rapidan well beyond the Confederate left flank and marched toward Fredericksburg. At the same time, two corps began to cross below Fredericksburg.

Within three days, Hooker was at the Chancellorsville crossroads. Lee rushed westward and attacked. Hooker lost his nerve, halted and set up a defensive line, which proved to be fatally weak on the right flank. "For once I lost confidence in Hooker," Hooker admitted, "and that is all there is to it."

That evening, Lee and Jackson met briefly for the last time (E. B. F. Julio's painting of that meeting would become a Southern icon). The next morning Jackson's corps made a risky twelve-mile march around Hooker's army. Everything depended on not being detected. Finally Jackson was in place, and with the eerie yell ringing in the air, his troops hit the Federal right flank like the wrath of God. The rebels were still advancing when darkness fell.

Then tragedy struck. Jackson, while on reconnaissance in front of his lines, was mortally wounded by shots from his own men. He fell with two bullets in his left arm, which had to be amputated. Learning of this, Lee said, "He has lost his left arm, but I have lost my right." Pneumonia set in, and Jackson died eight days later.

While the battle raged, Sedgwick's corps stormed Marye's Heights in Fredericksburg, driving off Early's few defenders, then marched toward Chancellorsville to assist Hooker. Lee, leaving four divisions to watch Hooker, turned and held Sedgwick off at Salem Church, six miles from Chancellorsville. On May 4, a badly shaken Hooker withdrew, soon to be shorn of command.

After the battle Lee said of his soldiers: "There never were such men in an army before. They will go anywhere and do anything if properly led." A cabinet minister said that "Lee's fame was so great that it now filled the world."

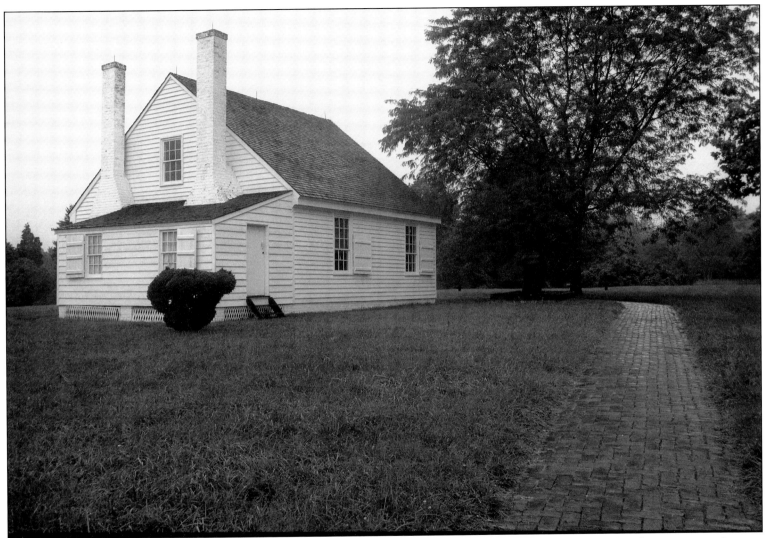

Stonewall Jackson, accidentally shot at Chancellorsville on the night of his most daring assault, was taken by wagon to the railroad station at Guinea Station. He was placed in the bedroom of a nearby plantation office, above, to rest before being moved to a Richmond hospital. He contracted pneumonia, however, and his condition steadily worsened. With his wife at his bedside, he died, on May 10, 1863. His last words were: "Let us pass over the river, and rest under the shade of the trees." Lee wept when he learned of the death of his greatest lieutenant, and the Confederacy mourned.

*V*ictory at Chancellorsville came at great cost. The most grievous loss was Jackson, but Lee suffered 13,000 other casualties, 22 percent of his army. And the battle gave Confederate morale a boost that would soon prove harmful. It bred overconfidence and a contempt for the enemy that would lead to disaster. Believing his men invincible, Lee would soon ask them to do the impossible.

To compensate for the loss of Jackson, Lee reorganized the Army of Northern Virginia, which now numbered 70,000, into three corps. Longstreet retained command of the First Corps. Richard S. Ewell, although handicapped by the loss of a leg, was given the Second Corps, and A. P. Hill the Third. The officers and men were supremely confident. Most had been campaigning for two years, and had almost always triumphed. Thoroughly trained, inured to hard service, they were as fine an army as ever took the field.

On the strength of Fredericksburg and Chancellorsville, Lee decided to again invade the North. Beginning on June 3, 1863, he began a march up the Shenandoah and Cumberland valleys. Hooker also headed north, but to the east of Lee. On June 27, Ewell, who commanded Lee's advance columns, reached the Pennsylvania town of Carlisle, about thirty-five miles north of Gettysburg. Meanwhile, Jubal A. Early had seized the town of York, about forty miles northeast of Gettysburg. To spare York from the torch, he was given supplies and paid $28,000.

A fatal mistake had been made. Jeb Stuart, taking advantage of a too general order from Lee, had led his cavalry on another ride around the Union army and had not returned. Lee was operating without the army's eyes and ears. Not until June 28 did Lee know that the Union army had crossed the Potomac two days before, and that Lincoln had appointed a new commander to lead it.

General George G. Meade, the new commander, promptly marched from Frederick, Maryland, toward Harrisburg, Pennsylvania to better protect the Baltimore-Washington area, concentrating his army several miles to the southeast of Gettysburg. Meanwhile, Lee, still not knowing where the Union army was, concentrated his army west of Gettysburg.

On June 30, a Confederate brigade entered Gettysburg, looking for a supply of shoes stored there. Discovering Union cavalry in possession of the town, they retired. The following morning, the Confederates returned in greater strength. Neither army commander chose the battlefield. The selection of the site for the greatest battle ever fought on the American continent was an accident.

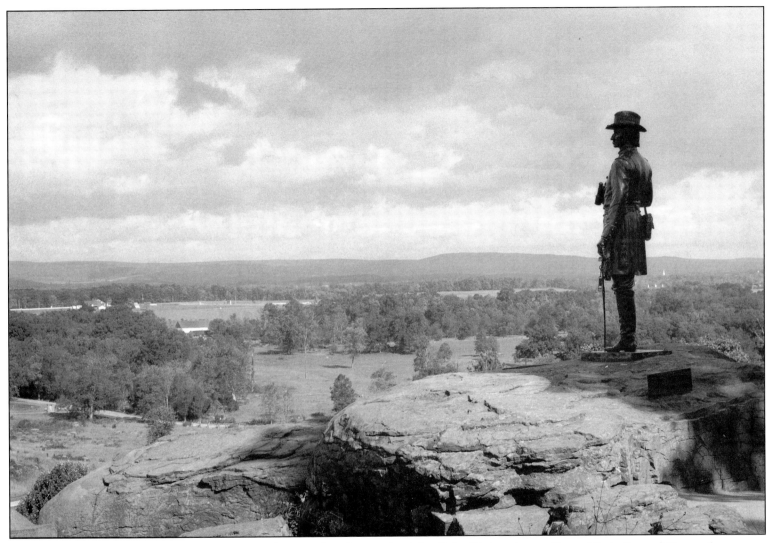

On the fateful second day at Gettysburg, luck seemed to be on the side of the Union Army. From Little Round Top, a key objective of both armies, a statue of Gouverneur Warren, Chief Engineer of the Union Army, surveys the battlefield. From here he called in reinforcements just in time to save the Union left. At the right are church spires in the town. Warren overlooks Devil's Den, the Valley of Death, the Wheatfield, and the Peach Orchard, all scenes of savage fighting. At day's end an aide told General Meade: "...they have hammered us into a solid position they cannot whip us out of."

On July 1 the two armies collided at Gettysburg. The day was a rebel success, but that night and the next morning Union troops took up a position on Cemetery Ridge and Little Round Top, both admirably suited for defense. The Confederates could have occupied Little Round Top but failed to do so. It was an error of dire consequences.

By the afternoon of July 2, Lee and Meade had their whole forces on the field. Lee had 75,000 men, Meade 88,000. The rebels occupied a rise, concave in form, called Seminary Ridge. Lee attacked from there around four in the afternoon. He apparently had not realized that Meade's position was so strong, and his attack was disastrously repulsed. Jeb Stuart joined Lee that day, but his cavalry was too exhausted to go into action.

The next morning, Lee and Longstreet made a reconnaissance of the Union position. Lee said he was going to attack the enemy center on Cemetery Ridge. Longstreet was stunned. He pointed out difficulties that lay between the two lines—hills, fences, woods. "Then we'll have to fight our infantry against their batteries. Look at the ground we'll have to charge over, nearly a mile of that open ground there under the rain of their canister and shrapnel."

"The enemy is there, General Longstreet, and I am going to strike him," Lee replied. Lee did not allow arguments about his commands. When he had made up his mind, discussion was over.

On the third day, the battle resumed at daybreak. The Confederate attacks the previous day had been uncoordinated, and Lee believed they had failed for that reason. He resolved to deliver a concentrated, fully coordinated attack on the Union center on Cemetery Ridge. Preceded by an artillery bombardment, the attack would be made by 15,000 of Longstreet's men. All but a division commanded by General George E. Pickett had fought the day before. Pickett had been guarding supply trains.

Longstreet was slow getting the attack going. The barrage began at one in the afternoon, and at three the troops sounded the rebel yell and marched out slowly and steadily with their battle flags flying. Their destination was "the little clump of trees," in the center of the Union lines on Cemetery Ridge, up a gentle incline three-quarters of a mile away.

Artillery opened fire, shot and shell tore through their lines, but somehow the rebels kept moving forward. Some succeeded in crossing the Union breastworks but there were not enough of them to hold what they had taken. They began to stagger back to their lines.

On the third day, Lee, now desperate, ordered a massive attack on the middle of the Union line. After rebel artillery bombarded Cemetery Ridge, 15,000 troops raced across the field in what is now called Pickett's Charge. Only half the men made it up the hill, and only a third survived the assault. Rebels, depicted in the North Carolina monument, above, seem to charge once more toward the "little clump of trees" on Cemetery Ridge which can be seen in the distance. These bronze figures were sculpted by Gutzon Borglum, who created the presidential faces on Mount Rushmore.

On Seminary Ridge, Lee saw Pickett and rode to his side. "General Pickett," he said. "place your division in the rear of this hill, and be ready to repel the advance of the enemy should they follow up on their advantage."

"General Lee," replied Pickett. "I have no division now. Armistead is down, Garnett is down, and Kemper is mortally wounded."

"Come, General Pickett," said Lee, "this has been my fight and upon my shoulders rests the blame. The men and officers of your command have written the name of Virginia as high today as it has ever been written before."

General Cadmus Wilcox rode up and began his report, but broke down and wept. "Never mind, General," said Lee, "all this has been my fault—it is I that have lost this fight, and you must help me out of it the best way you can. All good men must rally."

Only one field officer from Pickett's division had found his way back to the lines, the rest were dead or wounded. Garnett had led more than 1,300 men and had lost 941. The 38th North Carolina could only muster forty men. Company A of the 11th North Carolina, a hundred men strong an hour before, now had only eight and a single officer.

Meade did not counterattack. He respected Lee, and could scarcely believe he had beaten him. The Battle of Gettysburg was over. Union losses were 23,000; Lee lost about 20,000, a third of his army. The Union could easily replace its losses, but the manpower of the Confederacy was nearly exhausted.

On July 4 Lee began his retreat from Gettysburg in a driving rain. Meade did not press him. Ten days later the Confederate army was safely across the Potomac. Meade's army crossed a few days after that.

Early in August, Lee decided he should be relieved of command. He wrote Davis: "I therefore, in all sincerity, request Your Excellency to take measures to supply my place. I do this with [in the knowledge of] my inability for the duties of my position. I cannot even accomplish what I myself desire. How can I fulfill the expectations of others?" His request was not granted. Replied Davis: "To ask me to substitute you [with] someone in my judgment more fit to command, or who would possess more of the confidence of the army, or of the reflecting men of the country, is to demand an impossibility... "

Lee shouldered his heavy burden and went on. During the fall, the two armies maneuvered back and forth across northern Virginia, doing little damage to each other, until they finally went into winter quarters.

The frightful cost of Pickett's Charge is mirrored in the face of a figure on a monument created by sculptor Donald DeLue, which memorialized the 2,300 men of Louisiana who fought at Gettysburg. Three days of fighting at this small Pennsylvania town had cost the armies 51,000 casualties. July 4, 1863, was a black day for the Confederacy. As Lee's exhausted army began its retreat to Virginia, Grant accepted the surrender of Vicksburg and its 29,000 exhausted defenders, giving the Union control of the Mississippi River and splitting the Confederacy in two.

*L*ee's nemesis arrived in Virginia in March 1864. Ulysses S. Grant, in three short years, had risen from being a shabby, small-town drunkard to supreme commander of all Union armies. When Lee heard the news, he told his officers, "We must make up our minds to get into line of battle and to stay there, for that man will fight us every day and every hour till the end of the war."

Grant's objective was to destroy Lee's army. Capturing cities and the occupying of territory meant little, he believed. As long as Lee's army was in the field, the Confederacy lived; as soon as it was gone the Confederacy would die. Lee sensed what was coming. "We must destroy this army of Grant's before he gets to the James River," he said. "If he gets there it will become a siege, and then it will become a mere question of time."

Grant crossed the Rapidan in early May and marched down through a jungle-like stretch of second-growth timber known as the Wilderness, hoping to fight Lee in open country farther south. But Lee didn't like to fight where his opponent wanted him to. He marched straight into the Wilderness and jumped the Federal columns. The night before the battle, Lee had written: "If victorious, we have everything to live for. If defeated, there will be nothing to live for."

The Wilderness was so overgrown that neither artillery or cavalry could operate in it. Grant's numerical advantage meant little. The battle was blind and vicious. The woods caught fire, and many of the wounded burned to death. Smoke of the fire mixed with the smoke of battle to make a choking, blinding fog. At a crucial moment, Longstreet was accidentally shot by one of his own men, a wound that would keep him out of action for six months. Lee fought on. An aide said, "I would charge hell itself for that old man."

Grant lost more than 17,000 men without gaining one foot of ground. Both his flanks had been broken in, and a complete disaster had been narrowly avoided. By any indication, Grant had been beaten just as badly as Hooker at Chancellorsville. After a battle, the Union army usually retreated to lick its wounds. This time it advanced, and as Grant rode along the marching columns he was greeted by cheers.

Grant pushed on to Spotsylvania Court House, about twenty miles to the southeast. If he got there first, his army would be astride the best route to Richmond. He arrived to find Lee entrenched across his path.

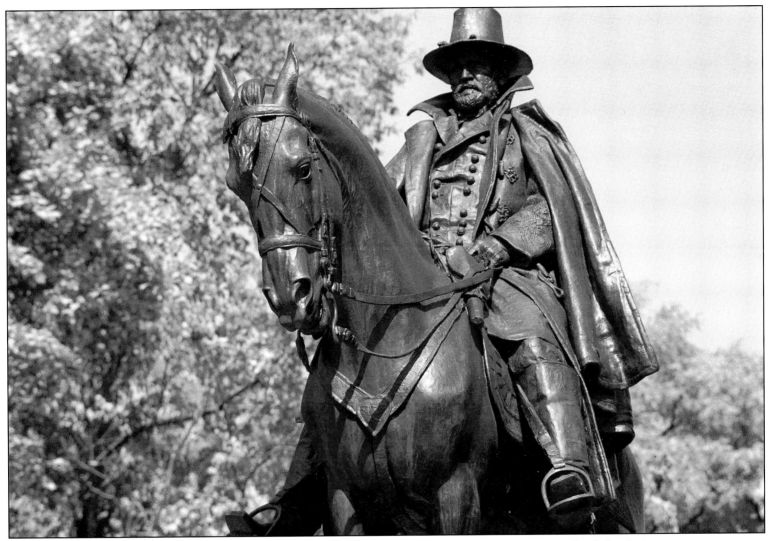

A statue of Lee's nemesis, Ulysses S. Grant, suggests why Lincoln said, "I can't spare this man—he fights." Few men were more different than Lee and Grant, except when they took the field. Neither clamored for reinforcements, complained, nor quarreled with associates. Both simply went ahead and got the job done. They fought some of the bloodiest battles of the war—The Wilderness, Spotsylvania and Cold Harbor—before Grant forced Lee into a defensive position in front of Richmond at Petersburg. Then Lee's military genius was not enough; it now was a war of numbers.

*S*potsylvania was a sprawling, twelve-day battle with fighting going on all the time somewhere along the opposing lines. On the morning of May 7, two Union corps charged from the woods opposite a vulnerable section of the rebel line known as the Mule Shoe Salient. In a dense fog, the initial assault nearly overwhelmed the Confederates, but as a second assault reached the line it was hit by rebel reinforcements.

Lee moved forward to lead his troops in a desperate counterattack. The soldiers shouted "General Lee to the rear!" and vowed to drive back "those people" if Lee would only stay safely behind the line. Lee acceded, and the division swept forward.

For eighteen hours, the Mule Shoe Salient was the scene of some of the most intense hand-to-hand fighting of the war, and at least 12,000 men fell, struggling for one square mile of ground. The front was so narrow that the Yankees were thirty ranks deep, those in the rear passing loaded muskets forward. Cannon fired canister at point-blank range, and soldiers were "stabbed to death... with bayonets thrust between the logs in the parapet which separated the combatants."

The desperate fighting at what became known as the "Bloody Angle" bought Lee sufficient time to build new earthworks, but Grant was not to be deterred. He telegraphed Washington declaring that "I propose to fight it out on this line if it takes all summer."

When the battle finally ended, Grant resumed moving to the left, skirmishing, probing for a weak spot. Lee parried his every thrust, but by May 19th he had to act or be cut off from Richmond. Ewell's corps, now down to 6,000 men, was sent to scout the strength of the Union right, but ran into a fresh division, and was fought to a standstill. The next night Grant marched south again.

Grant's losses during the past three weeks averaged 2,000 men a day. Lee's were considerably fewer, but Grant was being reinforced and Lee wasn't. A seemingly endless train of wagons bearing wounded men trailed south toward Richmond.

More bad news reached Lee on May 12. Grant had sent Philip Sheridan on a raid around the Confederate army with a strong cavalry force, and Jeb Stuart was in pursuit. When Sheridan headed toward Richmond, Stuart was able to cut him off and a pitched battle was fought at Yellow Tavern, north of Richmond. It was Stuart's last battle. A Yankee trooper put a bullet in his stomach, and he died the next day. Lee commented sadly, "I can scarcely think of him without weeping."

At Spotsylvania, Lee started to ride forward to lead a reserve division in a desperate counterattack. His soldiers shouted, "General Lee to the rear!" and vowed to drive back "those people" if Marse Robert would only stay behind. Lee acceded and the division swept forward. The face, above, on a statue honoring the 5th Regiment, New Jersey Volunteers, stands at the apex of the Bloody Angle, the scene of the fiercest hand-to-hand fighting of the war. Near the statue, a plaque marks where an oak tree, nearly two feet in diameter, was cut down by a hailstorm of minie balls.

Grant and Lee spent the month of May jockeying for position, always moving to the southeast, Grant never quite able to catch Lee at a disadvantage. He would disengage and march at night, only to find Lee waiting for him. There were constant skirmishes and probing attacks as the armies crossed the North Anna, the Pamunkey, and the Totopotomoy rivers.

Grant had five corps to Lee's three, and seemed to have a clear path to Richmond. "Lee's army is really whipped," he reported to Washington. "I may be mistaken, but I feel that our success over Lee's army is really assured." Lee told Davis that without reinforcements, he faced "disaster." Davis dispatched General Robert Hoke's division. Lee sent General Fitzhugh Lee's cavalry to secure Cold Harbor until Hoke arrived. Grant, also sensing the tactical importance of the Cold Harbor crossroads, sent Sheridan's cavalry to Cold Harbor, near the Chicahominy River and dangerously close to Richmond.

Grant ordered an attack for dawn, but a series of high-command problems forced its postponement for a day. Lee put the extra time to good use. "Intricate, zigzagged lines within lines, lines protecting flanks of lines, lines built to enfilade an opposing line, lines within which lies a battery," reported a newspaperman who later inspected the entrenchments. Amazingly, the Confederates were able to build the defenses so that they did not appear to the Federals to be as formidable as those at Spotsylvania or North Anna.

There was little room to maneuver, so on the morning of June 3 Grant sent his men straight at the earthworks in the hope of breaking the Confederate line once and for all. "To give a description of this terrible charge is simply impossible," wrote a Yankee officer. "That dreadful storm of lead and iron seemed more like a volcanic blast than a battle." Confederate General Evander Law said, "It was not war, it was murder."

Union casualties were ghastly; some 7,000 men had fallen, most of them in the first fifteen minutes. By comparison, the Confederates lost only 1,500. Incredibly, another Union attack was ordered two hours later, but officers and men simply refused to move and it was called off. The armies remained, facing each other in impregnable trenches, for another ten days.

Grant had lost the battle, but kept the initiative. Lee could not move now without exposing Richmond, but Grant could go where he pleased. On the night of June 12, the Army of the Potomac again marched south—this time toward the railroad hub of Petersburg, twenty-two miles south of Richmond.

At Cold Harbor, thinking that a breakthrough might win the war, Grant repeatedly attacked Lee's entrenched forces, suffering 7,000 casualties by the end of the day. "I think Grant has had his eyes opened," General Meade wrote to his wife, "and is willing to admit now that Virginia and Lee's army is not Tennessee and Bragg's army." The grave of an unknown defender, above, is still cared for 132 years after he fell in battle. Civil War casualties nearly defy comprehension. Should a war take a similar percentage toll of today's population, casualties would exceed six million.

Grant left Cold Harbor behind a cavalry screen, crossed the Peninsula east of Richmond, then crossed the James River. Lee thought Grant was headed for Richmond, but his destination was Petersburg, twenty miles south of Richmond, through which passed all but one of the railroad lines to the Confederate capital. If Petersburg fell, and if that one remaining railroad were cut, Richmond and Lee's army would be without food and supplies, and the Confederacy would be doomed.

Only luck kept Petersburg from falling immediately. The city was protected by earthworks, but manned by only 2,400 Confederates. Grant ordered General W. J. Smith to attack with 16,000 troops on June 15. He broke through, but he was slow in following up, and rebel troops rushed to close the gap in the lines. Grant disgustedly began a siege, which would drag on for nearly a year.

Lee set to work strengthening the fortifications and extending them to the west. The Federals also were building an elaborate system of earthworks of their own. Grant brought in long-range mortars to lob explosive shells into otherwise inaccessible rebel trenches. Sharpshooters were poised to pick off anyone who raised his head above the parapet. Both armies built bombproofs and shelters, settling down for a long siege.

Lee once dismounted under fire at Petersburg to pick something from the ground and place it in a tree. After he rode off, curious soldiers investigated and found that he had replaced a fallen baby bird in its nest.

Walter H. Taylor, Lee's assistant adjutant general, found a place called Violet Bank north of the city for Lee's headquarters. Lee chose to live in a tent on the lawn because the house "was entirely too pleasant for him, for he never is so uncomfortable as when comfortable."

No major attempt was made to breach the Confederate lines until Colonel Henry Pleasance, a mining engineer before the war, proposed blasting a way through the defenses. He proposed building a 500-foot tunnel under the Confederate lines. An enormous charge of gunpowder in the tunnel would blow a huge hole in the lines. Troops would dash through the hole and go on to capture Petersburg.

The gunpowder blasted a crater 170 feet long, 60 feet wide, and 30 feet deep. Federal soldiers rushed into the crater and couldn't get out, and rebels shot them like fish in a barrel. Lee watched the hand-to-hand fighting at the crater that eventually forced more than a thousand Yankees to surrender.

Failing to capture Richmond by his suicidal attacks at Cold Harbor, Grant swung south to assault Petersburg, the rail center supplying Lee's army and Richmond. After four days of unsuccessful attacks, Grant decided to lay siege and starve out the defenders. The siege would last ten months, with the armies in almost constant contact. A reconstruction of a typical section of the siege line, above, includes a communication trench, a defense line of pointed stakes called a fraise, a mortar, and underground shelters called bombproofs.

As the siege dragged on, City Point, population 100, a sleepy river town on the James, suddenly found itself one of the world's great seaports, with Union bakeries, barracks, warehouses, a two-hundred-acre tent hospital, and more than a mile of wharves. Food and war materiel poured ashore, a flood tide of transports and barges. By the spring of 1865, more than 280 new buildings of all descriptions had been built. A major telegraph system was installed to relay information from Washington to the battlefield and back. The army built a twenty-one mile railroad and ran eighteen trains a day to bring supplies and fresh troops right up to the Federal trenches. "Not merely profusion but extravagance," a Southern churchman wrote, "wagons, tents, *ad libitum*. Soldiers provided with everything."

On the last Thursday in November, proclaimed Thanksgiving Day by Lincoln (perhaps because he had won reelection earlier that month), the Federal army at Petersburg enjoyed a feast of turkey or chicken, pies and fruits. For Lee's army, reported General Gordon, it was "starvation, literal starvation." Lee said that, "Some of the men have been without meat for three days, and all are suffering from reduced rations and scant clothing... "

The riches pouring into City Point were a symbol of the Union's great advantage in the war—it simply had more than enough of everything. On the eve of war, there were more than 22 million people in the North. The south had 9 million, and more than a third of them were slaves. The North controlled 90 percent of the country's manufacturing capacity, two-thirds of its railroad mileage, and most of its deposits of iron, coal, copper and precious metals. Control of the Atlantic gave the North access to the factories of Europe. Huge surpluses of food produced in the North could be sold to pay for quantities of munitions. And as the war dragged on, the industrial and agricultural capacity of the North continued to grow. The North never experienced a shortage of anything.

During the siege, Grant made his headquarters at a plantation in Hopewell near City Point, named, ironically, Appomattox Manor. He lived and worked there, first in a tent erected on the lawn and later in a rude cabin. Lincoln used the drawing room of Appomattox Manor as his office when he came to confer with Grant.

Lincoln visited City Point twice. He joined Grant in June 1864 for a visit to the Petersburg front. He was back in March 1865, and spent two weeks in meetings with Grant, Sherman and others on the President's ship, the *River Queen*, moored just off shore. A day after the meeting, Grant moved closer to the Petersburg front and began his final spring offensive.

While Lee and his outnumbered army suffered in the trenches before Petersburg, shiploads of food and supplies arrived daily for the Union forces. A special twenty-one mile railroad was built and eighteen supply trains a day sped to the front. A Confederate officer wrote home, "It is hard to maintain one's patriotism on ashcake and water." Grant's headquarters during the siege and the nerve center of the Union war effort was in the restored rude cabin, above, on the lawn of Appomattox Manor Plantation, at City Point. Cabins and tents filled nearly every square foot of the plantation grounds.

A carriage from Petersburg carrying a flag of truce came through the rebel lines on the afternoon of January 31, 1865. In it were commissioners on their way to discuss terms for a negotiated peace with Lincoln. As it crossed no man's land, men in blue and gray lined the parapets by the thousands. An observer noted, "Cheer upon cheer was given, extending for some distance to the right and left of the lines, each side trying to cheer the loudest." Lincoln forbade the meeting, telling Grant to "press on to the utmost his military advantages."

Constant sniping from Federal sharpshooters and a steady stream of deserters were slowly eroding Lee's already undermanned defenses. It had become a war of attrition, Grant continually extending his lines to the left, forcing Lee to stretch his line to the utmost. By February, Lee was defending a fifty-three mile network of trenches.

President Davis appointed Lee General in Chief of the Armies of the Confederate States in February 1865, a move that came too late to change the course of events. Lee immediately persuaded Davis to put Joseph Johnston in command of all troops in the Carolinas. Lee also proposed bringing black troops into the army. Two black companies were formed in Richmond, but served as hospital orderlies and were not issued uniforms.

Lee planned an assault on Fort Stedman at the northern end of the Union fortifications. He hoped that after they broke through, the troops could attack other Union defenses from the rear. It was a desperate move, but the times were desperate. Sheridan was reported on his way to Petersburg, to add his 10,000 cavalrymen to Grant's already monstrous army.

Confederate troops captured Fort Stedman just before dawn on March 25, then seized two batteries on either side of it. But Union reserves drove them back, inflicting heavy casualties. When it was over Lee had lost nearly 5,000 men in what proved to be the last major offensive he ever would make.

Lee wrote to Davis: "... I fear now it will be impossible to prevent a junction between Grant and Sherman, nor do I deem it prudent that this army should maintain its position until the latter shall approach too near."

Four days later. Grant began his last turning movement, ending in a victory by Sheridan in the Battle of Five Forks on April 1. The commander there, George Pickett, and three of his generals were away at a shad bake, and Lee would remove him from command within days.

When news of the victory reached the Union troops at Petersburg, guns and mortars began a tremendous bombardment that went on for hours, while troops moved out silently and prepared to attack at dawn.

The Washington Artillery of Louisiana, composed of the rich, socially prominent young men of New Orleans, was the most famous artillery unit of the war. They went to war with their own cook, staged elaborate shows to entertain the troops, and still found time to fight with distinction in every battle in Virginia, from First Manassas to Appomattox. Their battle flag, incorporating the outline of a cannon barrel, now identifies a reenactor at the Petersburg National Battlefield. In the summer reenactors fire vintage cannon to give visitors a sense of life in the fortifications that protected the approaches to Richmond.

*L*ee heard the thunder of the Union guns as he was trying to rest at his headquarters. First Longstreet arrived, then A.P. Hill. Then a colonel burst in to say that Union troops had broken through the line. Longstreet and Hill immediately left to be with their men. Lee arose, dressed in his best uniform, and put on his finest sword. He went out into the gray morning of Sunday, April 2. He rode forward and saw thousands of Yankees advancing toward the Confederate lines. A courier rode up and said A.P. Hill had been killed leading his troops.

The Confederate lines were falling apart, and Lee knew the long battle to defend Richmond was lost. He telegraphed the Secretary of War that he would have to abandon the Petersburg defenses and advised "that all preparation be made for leaving Richmond" that night. A similar message was delivered to President Davis while he was attending services at St. Paul's Church in Richmond. The death knell of the Confederacy was sounding.

Lee took personal charge of the six cannon defending his headquarters, but Union shells fell on the house and it went up in flames. Meanwhile, one desperately defended position after another was being overwhelmed. At eight that evening, the remnants of the Army of Northern Virginia began to withdraw from the lines. Five roads led west to Amelia Court House, forty miles away, where they would rendezvous. Over these roads had to pass 1,000 wagons, 200 pieces of artillery, and regiment after regiment of infantry and cavalry. Gunpowder which could not be moved was blown up in the storage magazines.

In Richmond there was rioting. Hoodlums plundered stores and set buildings on fire. The lower part of the city was a sea of flames. When the fire reached the arsenal, hundreds of thousands of shells there began to explode, their din drowning out the sounds of the frightened crowds. Davis and his Cabinet left the capital by train, taking what was left of the Confederate archives and the gold from the treasury. Before dawn, Federal troops began to occupy the city. They met no resistance and set to work trying to bring the fire under control.

West of the city, the long columns of Lee's retreating army stretched out for thirty miles. Every stream was an obstacle; there were never enough bridges to accommodate the weary troops and their equipment. Lee had arranged for rations to be sent by train to Amelia Court House, but in the haste and hysteria something had gone wrong and the train never arrived. The sparsely settled area had few towns and farms; there was nothing for Lee's thousands of men to eat.

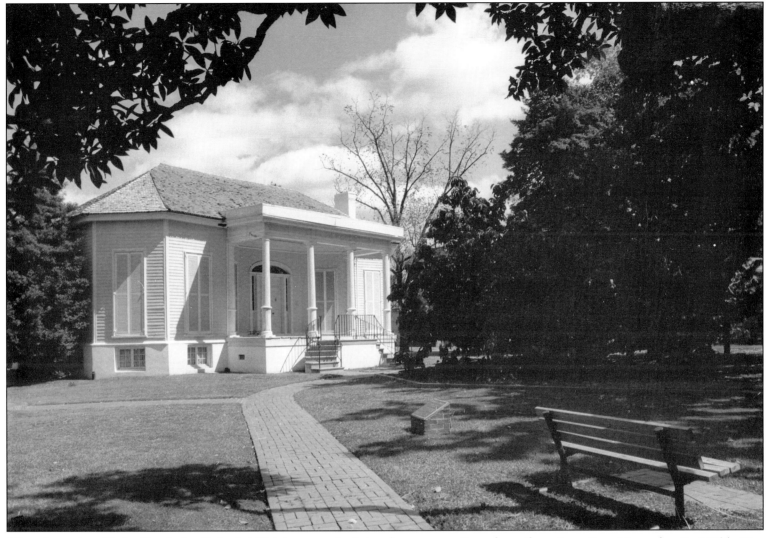

The plantation Violet Bank, in Colonial Heights, was Lee's headquarters at Petersburg from June 8 to November 1, 1864. He lived in a tent on the lawn. He wrote his wife: "It is from no desire of exposure or hazard that I live in a tent, but from necessity. I must be where I can speedily and at all times attend to the duties of my position and be near or accessible to the officers with whom I have to act." It was here, on the morning of July 30, that he received news of the explosion at the Crater. He was forced to move his headquarters in the autumn when the falling leaves exposed his position to the enemy.

*L*ee was attempting to pull back from Petersburg, reorganize his army, march his troops west to the railroad, and move them south to join Joseph Johnston and his army in the Carolinas. The situation was becoming a nightmare. Finding no rations waiting at Amelia Court House, Lee paused to allow the troops to forage for food. The delay would prove fatal.

Grant's pursuit was swift and skillful. Sheridan blocked the railroad that ran south to Danville and Johnston's army, and Lee had to change his objective to Lynchburg, some sixty miles to the west. During the past year, these two armies had raced each other to such strategically important places as Spotsylvania Court House, Cold Harbor, and Petersburg, and now the soldiers sensed this was the final race. "We grew tired," a Yankee soldier wrote, "but we wanted to be there when the rebels found the last ditch of which they had talked so much."

The rebel army was bone-tired and hungry. Grant smelled victory. Union cavalry rounded up hundreds of rebels who fell exhausted by the roadside. At a stream named Sayler's Creek on April 6, three Union corps cut off part of Lee's army, took 6,000 prisoners, including Richard Ewell and five other generals. George Custer's cavalry division seized four wagon trains of Lee's supplies. "My God!" exclaimed Lee, when he learned of the defeat. "Has the army been dissolved?"

The next day, as the weary rebels trudged westward, Grant sent Lee a message, calling on him to surrender. Notes went back and forth, but no agreement was reached. Grant finally commented, "It looks as if Lee means to fight." Lee did mean to try to break through Sheridan's troopers blocking the road near Appomattox Court House. On April 9, rebel yells shattered the stillness as Confederates drove back the Union cavalry, only to discover two infantry corps coming into line behind the troopers. Two other Union corps were moving quickly towards Lee's rear to close the trap.

As Grant prepared to attack, the rebels waited by their red battle flags. Nearly surrounded, outnumbered five to one, Lee faced the inevitable. An aide suggested that the men could take to the woods and become guerrillas. Lee dismissed the idea. He said guerrillas "would become mere bands of marauders, and the enemy's cavalry would pursue them and overrun many sections they may never [otherwise] have occasion to visit. We will bring on a state of affairs it would take the country years to recover from." With a sigh, Lee decided that "there is nothing left for me to do but go and see General Grant, and I would rather die a thousand deaths."

After Grant broke through the defenses at Petersburg, Lee's little army headed west. At the Battle of Sayler's Creek, on April 6, 1865, near the Hillman House, Lee's troops broke through a battery, above, only to be stopped by more batteries just behind the house. A mass surrender followed, including several generals, many colonels, and 7,000 troops—the largest battle surrender of the war. Confederate supply trains reached Appomattox Station, but were captured. The railroad to Danville was cut. Lee's army now had nothing to eat and no where to go.

*L*ee sent a note to Grant agreeing to surrender, and for the formalities they went to Appomattox Court House and the home of Wilmer McLean. In 1861, McLean was living near Manassas when a shell had crashed into his dining room. He moved here, only to find the final drama of the war played out in his living room.

Lee asked an aide what the country would think of him for surrendering. "Country be damned!" the aide replied. "There is no country. There has been no country for a year or more. You are the country to these men." Lee paused, then spoke of the people of the South, their bleak future, and the need to help their recovery.

Lee, fifty-eight, five feet eleven and erect in bearing, arrived in his dress uniform. Grant, forty-two, five feet eight with stooped shoulders, came in his usual private's blouse with his trousers tucked into muddy boots. The son of an Ohio tanner then began dictating terms to the scion of a First Family of Virginia.

The terms were generous. Officers and men could go home "not to be disturbed by U. S. authority so long as they observe their paroles and the laws in force where they may reside." This guaranteed Confederate soldiers immunity from prosecution for treason. Lee explained that in his army enlisted men in the cavalry and artillery owned their horses, and asked if they could keep them. Grant said privates as well as officers could keep their horses "to put in a crop to carry themselves and their families through the next winter." "This will have the best possible effect upon the men," said Lee, and "will do much toward conciliating our people."

After signing the documents, they saluted somberly and parted. "I felt... sad and depressed," Grant recalled, "at the downfall of a foe who had fought so long and valiantly, and had suffered so much for a cause...."

Union batteries began firing salutes until Grant ordered them stopped. "The war is over," he said. "The rebels are our countrymen again, and the best sign of rejoicing after the victory will be to abstain from all demonstrations." Grant ordered three days rations for 25,000 men sent across the lines.

Lee rode back to the remnants of his army. Soldiers crowded around Traveller, asking, "General? General, are we surrendered?" Lee took off his hat, and said, "Men, we have fought the war together, and I have done the best I could for you. You will all be paroled and go to your homes...." Tears flooded his eyes. He tried to continue but only managed to say, "Good-bye."

The uncomprehending soldiers tried to reassure their leader. "General, we'll fight 'em yet." "We'll go after 'em again." As Lee rode slowly away, some patted Traveller, others would grasp Lee's hand and walk along for a few steps, like a child beside a father, sobbing.

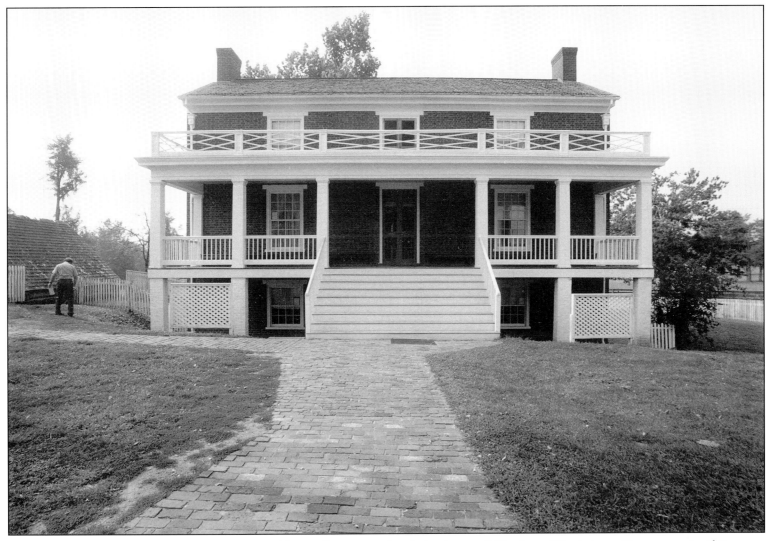

In the McLean House at Appomattox Court House, Lee surrendered the Army of Northern Virginia to Grant, on April 9, 1865, Palm Sunday. Officers and men could keep their horses and, in Grant's words, "each... man will be allowed to return to his home, not to be disturbed by the United States authorities...." Although several Confederate armies remained in the field, Lee's surrender signaled the end of the war. The North rejoiced. Ironically, at Manassas, troops had overrun the Wilmer McLean farm; he moved here to get away from the war only to have it end in his parlor.

*U*nion troops lined both sides of the road leading into Appomattox the day the Army of Northern Virginia was formally surrendered. Three days before Lee and Grant had met in the McLean House and agreed on terms. The day dawned cold and gray. General John Gordon represented Lee at the ceremony; General Joshua Chamberlain, the hero of Little Round Top at Gettysburg, represented Grant. Chamberlain's troops watched intently as the gray Confederate column crossed the valley and approached the town. "On they came," he wrote later, "with the old swing route-step and swaying battle flags."

General Gordon led the column of 28,000 grim-faced rebels. Immediately behind him was the Stonewall Brigade, now barely 200 men. Gordon sat erect in the saddle, but his head was down. As the column neared the double line of Union soldiers, Gordon heard a spoken order, a bugle call, then the clatter of hundreds of rifles being raised in salute. Gordon's head snapped up, and he wheeled his horse toward Chamberlain. As the animal reared, he raised his sword, then brought its tip down to his toes in a sweeping response to the Union tribute. He shouted a command and the Army of Northern Virginia returned the salute.

It was, Chamberlain said, "honor answering honor," and it was hard to say who was more moved emotionally. Confederate Major Henry Kyd Douglas said, "Many of the grizzled veterans wept like women, and my own eyes were as blind as my voice was dumb." Chamberlain said: "On our part, not a sound of trumpet more, nor roll of drums; not a cheer, nor word... but an awed stillness rather, and breath-holding, as if it were the passing of the dead."

After the exchange of salutes, the ragged veterans in gray turned to face Chamberlain, dressed their lines, fixed their bayonets, and stacked their rifles. Then, said Chamberlain, "lastly—and reluctantly, with agony of expression—they folded their flags, battle-worn, and torn, blood-stained, heart-holding colors, and lay them down." The next day "over all the hillsides in the peaceful sunshine, are clouds of men on foot or horse, singly or in groups, making their earnest way as if by the instinct of an ant, each with his own little burden, each for his own little house."

Most of them were gone by evening. The mighty Army of Northern Virginia was no more.

In Search of Robert E. Lee

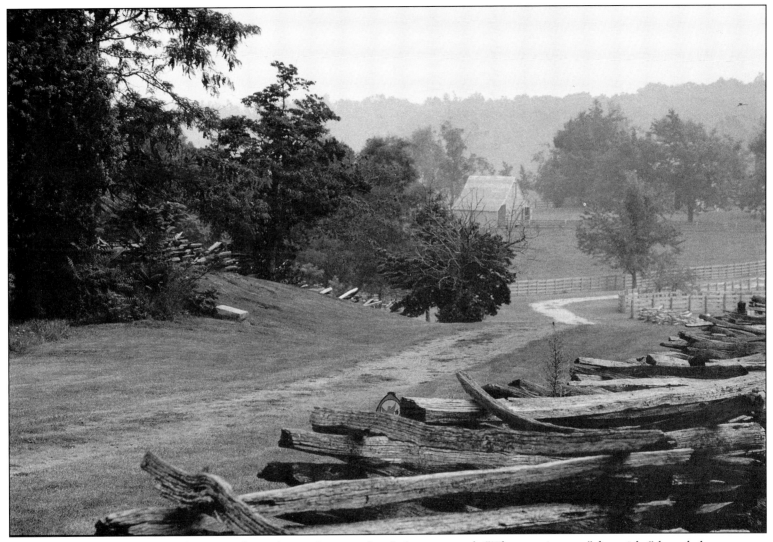

After the surrender, batteries began to fire salutes. Grant ordered them stopped. "The war is over," he said, "the rebels are our countrymen again. The best sign of rejoicing after the victory will be to abstain from all demonstrations." Up this road three days later, shrouded by a morning mist, marched the defeated but proud veterans of Lee's great Army of Northern Virginia. They surrendered their arms and their battle flags and received their paroles. As they marched by, a Union general ordered his men to present arms. The rebels returned the salute, a soldier's farewell.

*T*wenty-five Union cavalry troopers were sent to escort Lee on his way to Richmond, but he declined and rode off accompanied by only a few members of his staff. They took the wagon that served as Lee's office, and an ambulance wagon to carry a wounded staff officer. Six days after Appomattox the forlorn caravan arrived in a drenching rain at the pontoon bridge across the James. Lee was soaked to the skin. Lee saw the fire-gutted buildings of Richmond; from the Capitol to the waterfront, everything was in ruins.

When Lee entered the city a crowd quickly gathered. People cheered when he came into view. He lifted his cap time and again, acknowledging the tributes. A crowd awaited him at his three-story brick townhouse at 707 East Franklin Street. The people, young and old, wanted to take his hand or touch his uniform. Some sobbed. Lee himself was on the verge of losing his self-control. He grasped as many hands as he could, entered the gate and climbed the stairs. A last bow, then he entered the house where his family waited for him.

Later that day, April 15, news reached Richmond of Lincoln's assassination. It was the ultimate disaster. Lincoln's wise and tolerant policies now would give way to those of vengeful Northern radicals. Some of Lee's staff wanted to go to Mexico, Lee pleaded with them to reconsider. "Do not leave Virginia," Lee said. "She needs her young men now."

While Davis and his Cabinet were still making their way south, Lee wrote to him, counseling, "A partisan war may be continued, and hostilities protracted, causing individual suffering and the devastation of the country, but I see no prospect by that means of achieving a separate independence.... To save useless effusion of blood, I would recommend measures to be taken for suspension of hostilities and the restoration of peace."

A few days after Lee arrived home, Matthew Brady came to the house unannounced and convinced Lee, whom he had met during the Mexican War, to be photographed. He took photographs of Lee at the rear of the Franklin Street house, and the best of them are among the finest of all Lee portraits. Only these show him in the uniform worn when he met Grant at Appomattox. Lines of suffering and sadness are evident in Lee's face.

Men like Lee who had served the Confederacy in high positions were being singled out as special targets for the new administration in Washington. Davis had been apprehended and was being held as a prisoner. Lee had applied for a pardon, but now he was told he would be tried for treason. Lee wrote to Grant, asking for the restoration of his rights. His rights weren't restored, but the move to arrest him was quietly dropped.

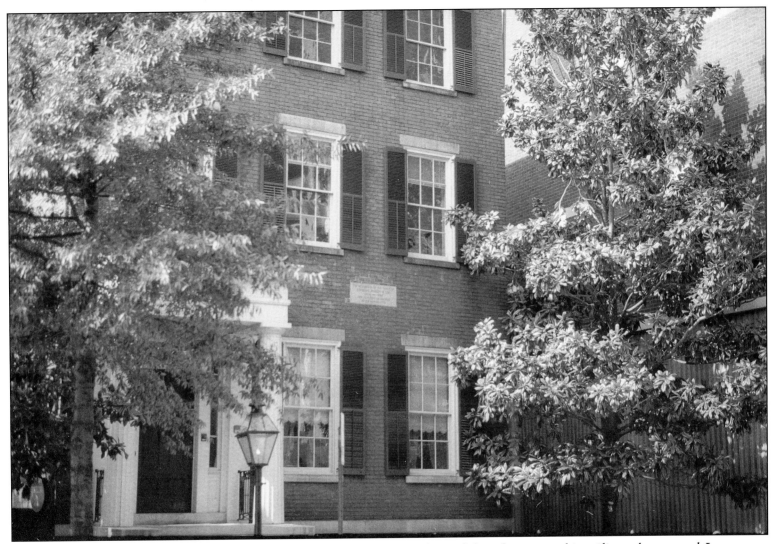

This three-story brick townhouse was offered to Lee in 1861 by a Richmond friend to use as his military home, and Lee gratefully accepted. The first person to live there, though, was Lee's son Custis, who was in the capital serving as an aide-de-camp to Jefferson Davis. He and some other young officers used the house as a bachelor's mess, and as a place to entertain their friends. In 1864 Lee took over the house from his son to use as a home for his wife Mary, who wanted to live in Richmond. He joined her there when he was in Richmond.

Now that the war was over, Robert E. Lee was anxious to get away from Richmond. "I am looking for some little, quiet home in the woods, where I can procure shelter and my daily bread...I wish to get Mrs. Lee out of the city as soon as practicable."

An opportunity soon came. A granddaughter of the statesman Edmund Randolph, Elizabeth Randolph Cocke, owned Derwent, an estate near Richmond in Powhatan. She wrote to the Lees, offering them the cottage on the estate and the Lees accepted. Early in June Robert and Mary Lee and their daughters took the packet boat to Derwent. They were met at the landing by Custis Lee, who had ridden Traveller from Richmond, and the son of their hostess, Captain Randolph Cocke.

The Lees were persuaded to stay for a week at Oakland, the home of their hostess, before moving into the four-room cottage. After the noise of Richmond, the stillness was a blessing. "A quiet so profound," wrote Mary, "that I could even number the acorns falling from the splendid oaks that overshadowed the cottage." She also praised the hospitality of their neighbors, but concluded: "My heart sinks when I hear of the destitution and misery which abounds in the South."

Lee enjoyed his life at Derwent. He took long rides on Traveller, and he spent hours getting reacquainted with his daughters. But he could not ignore the sufferings of the Southern people, nor the mistreatment of his friend Jefferson Davis. He felt powerless, particularly because he still had not received his pardon from the government. He began planning a history of his campaigns, explaining that it was "the only tribute that can be paid to the worth of [the army's] noble officers and soldiers." He wrote to his general officers and asked them to send along what records they might have to serve as background material for his book.

Lee wanted to find work. His financial resources were meager. Corporations offered him positions of honor with substantial salary, but he refused them all. "They are offering my father everything but the thing he will accept," said one of his daughters, "a place to earn honest bread while engaged in some useful work." By chance, she was talking to a trustee of a little college in a small town in the Shenandoah Valley. Her candor would change her father's life.

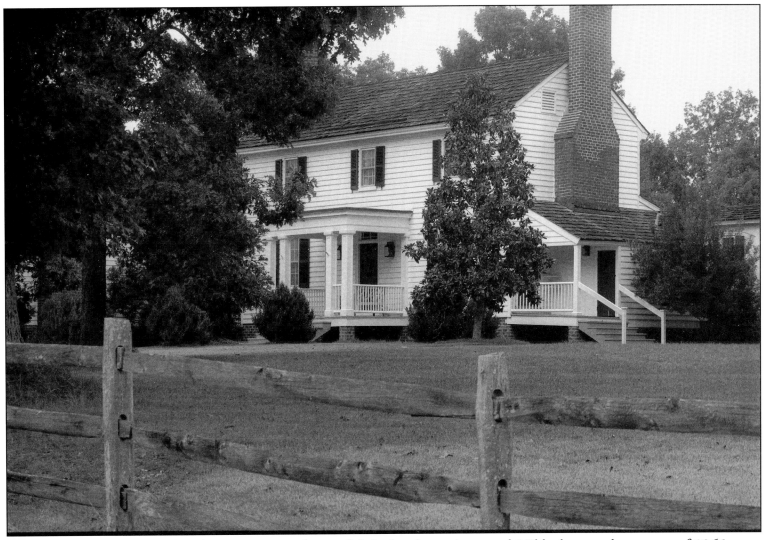

At the invitation of family friends, Lee, Mary and two of their daughters, Agnes and Mildred, spent the summer of 1865 at Derwent, a small plantation near Richmond. Lee spent much of this time encouraging his fellow Southerners to unite in efforts to obliterate the effects of the war and restore the blessings of peace, to take such work as they could find, to participate in elections, and to labor to rebuild their wasted land. While he was here, a message arrived offering him the presidency of little Washington College. He saddled Traveller and rode to Lexington to meet the trustees.

*T*he trustees of Washington College were trying to find a way to keep it going. Like its next-door neighbor in Lexington, the Virginia Military Institute, it had been heavily damaged during an 1864 Union raid, and now only four teachers and a handful of students remained. The little college was nearly destitute.

When the other trustees were told that Robert E. Lee might consider becoming president of the college, they unanimously elected him, and dispatched the rector of the college, Judge John W. Brockenbrough, to persuade him to accept.

Lee had turned down several offers, refusing to let his name be used in a business venture. He refused the vice-chancellorship of the University of the South because the school was denominational, and an offer from the University of Virginia because it was a state institution.

Lee was interested in Washington College but hesitant to commit himself. W.N. Pendleton, Lee's chief of artillery and now rector of Grace Church in Lexington, urged him to accept. But Lee, despite nearly three years as superintendent at West Point, was not confident he would be an effective president. He also feared that because he had not been paroled his appointment might "draw upon the college a feeling of hostility... ."

Finally he accepted, and the trustees were overjoyed. His salary would be $1,500 a year plus 20 percent of the tuition fees received and the use of a house on the campus.

Lee set out on Traveller for the three-day journey to Lexington, where he was inaugurated in a simple ceremony. When the president's house was ready, Mary and their son Robert joined him. Custis was a teacher at the Virginia Military Institute in Lexington. Robert wrote, "We were all very grateful and happy—glad to get home—the only one we had had for four long years."

Robert said that his father "at once set to work to improve all around him, laid out a vegetable garden, planted roses and shrubs, set out fruit and yard trees, made new walks and repaired the stables, so that in a short time we were comfortable and very happy. He at last had a home of his own, with his wife and daughters around him, and though it was not the little farm in the quiet country for which he had so longed, it was very near to it, and it gave rest to himself and those he loved most dearly."

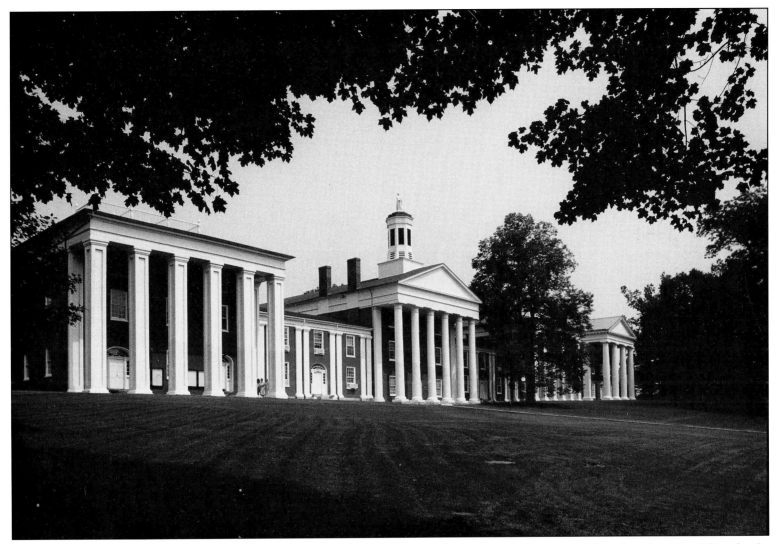

These buildings, comprising the antebellum colonnade of Washington College, were built between 1824 and 1842. The school was called Liberty Hall Academy when George Washington gave it a hundred shares of stock in the James River Company, and renamed Washington Academy in 1798, becoming Washington College in 1813. When Lee was made president, his salary was $1,500 a year plus 20 percent of the tuition fees received, and a house. He added many practical courses to the curriculum, including commerce and journalism. During his first year, the student body increased from 50 to 146.

*L*ee took his new duties seriously. Lacking adequate clerical help, he did a lot of the routine work himself. His former soldiers wrote to him constantly, and he answered all their letters. Oddly, there were few hostile letters, though some Northern newspapers still charged him with being a renegade and a traitor. He did not reply to such attacks.

In January 1866, the trustees sent Lee to Richmond to appeal to the legislature for funds. Later in the year, he was summoned to Washington to appear before a Congressional committee investigating the advisability of allowing the states which had seceded to be represented in Congress. His testimony did not receive much attention, but it is worthy of note. He said the people of his community were willing to have blacks educated, and that it would be better for both blacks and whites if they were.

As to secession, he said Southerners felt "the state was responsible for the act; not the individual," and that in his case the act of Virginia in withdrawing herself... carried him along as a citizen of the state, and that her laws and acts were binding on him. He agreed that the Confederate veterans felt more kindly toward the Federal government than any other segment of the population of the South. "They [the veterans] looked upon the war as a necessary evil and went through it."

Back in Lexington, he used his influence to raise funds for the college. Cyrus McCormick and George Peabody were among his Northern contributors, and even the abolitionist Henry Ward Beecher urged support of the fund drive. He also made changes in the educational program. Like most colleges then, Washington College stressed a classical education. Lee realized that the students needed practical training to help them earn a living. He offered chemistry and mechanics, civil and mechanical engineering, and modern languages, and recommended courses in agriculture, commerce, and journalism. He instituted an elective system to replace rigidly prescribed courses, and put the students on their honor. His office door was always open to students. Despite his background, he wanted the college to be run as a civilian place of learning. Virginia Military Institute was next door, and young men who planned a military career could go there. Once a new student asked him for a copy of the college's rule book. "We have no printed rules," Lee explained. "We have but one rule here, and that is that every student must be a gentleman."

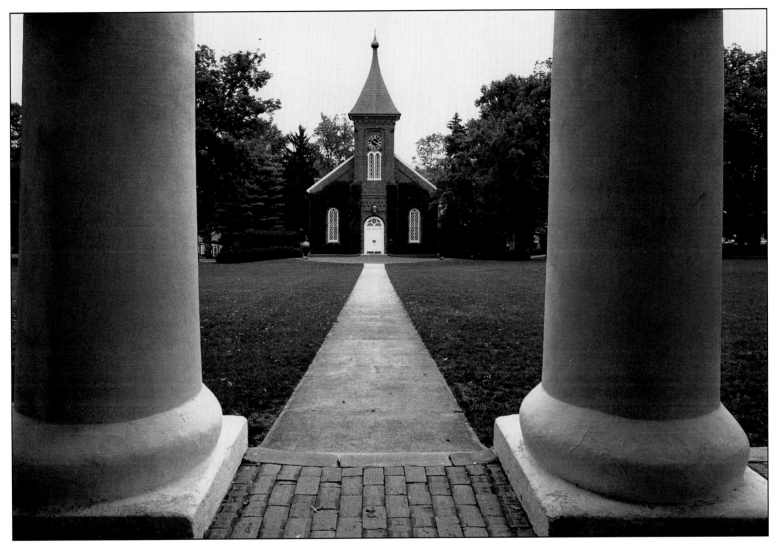

At Lee's request, in 1866 the trustees of Washington College appropriated funds to build a chapel on the college grounds. A simple Victorian design was proposed by Lee's eldest son, General George Washington Custis Lee, then a professor at the neighboring Virginia Military Institute. The Lees, father and son, gave close personal supervision to its construction. It was completed in 1868, in time for graduation. Lee moved his office to a room in the basement of the chapel. It was simply furnished, containing none of the trappings usually associated with a college president or a great general.

*L*ee exercised by riding his beloved Traveller, who had served him through the war, and they were a familiar sight around Lexington. His health was deteriorating, and photographs taken between 1865 and 1870 show that he was aging rapidly.

When summer came, the Lees would take the waters at the Greenbrier Hotel at White Sulphur Springs. William Wilkins Glenn, who observed him there, said the general seemed happiest when he could find "a nice little girl, young, fresh, or two at a time, and forget himself for a moment. With ladies," he added, "he will talk rather soberly but somewhat freely. With men not at all. It was painful to be with him. He reminded me of a man who feels that life has closed over [him] and that there was nothing left for him but death."

Lee visited Alexandria, where he had grown up, and where many of his old friends still lived. When he returned, he was asked how he had enjoyed his visit. "Very much," he said, "but they make too much fuss over an old rebel."

During the autumn of 1869, Lee caught a severe cold which persisted for a long time. "Traveller's trot is harder on me than it used to be and fatigues me," he wrote to his son Rooney, adding, "We are all as usual—the women of the family very fierce and the men very mild."

Lee went to Savannah with his daughter Agnes, and a large crowd greeted them at the railroad station. Lee enjoyed visiting with his old comrade-in-arms Joseph E. Johnston. Writing to his wife, Lee said: "The warm weather has dispelled some of the rheumatic pains in my back, but I perceive no change in the stricture in my chest. If I attempt to walk beyond a very slow gait, the pain is always there." The pain was a symptom of angina.

Back in Virginia, he went to the studio of the young sculptor Edward Valentine, who took careful measurements of Lee for a portrait bust. He asked if he should come to Lexington to finish the bust immediately or in the fall. Lee quietly advised him to come immediately.

When the fall term opened, Lee went about his duties, spending most of his time in his modestly furnished office in the basement of the new chapel. On September 27, he attended a faculty meeting for the last time. The next day was cold and rain began to fall in the afternoon. He went home for his midday meal and took a short nap. A vestry meeting was to be held in Grace Church at four o'clock. Despite the rain, Lee put on his military cape and walked to the meeting.

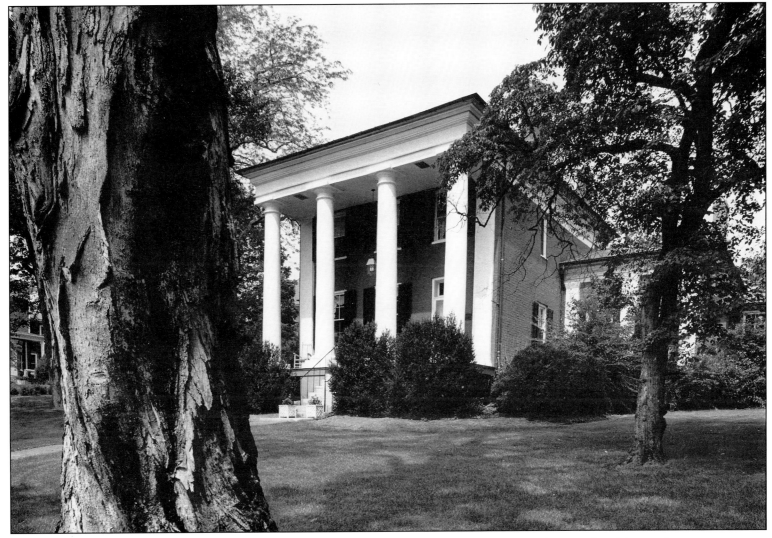

A new home, designed to accommodate Mrs. Lee's infirmities, was built for the Lees next door to the old President's House. Her bedroom was placed on the first floor, and she could go out onto the wide porch with her wheelchair. Lee's favorite spot was a comfortable chair by the large windows in the dining room, from which he could look out across the campus and, in the other direction over the fields to the mountains. Friends believed he was more content here at Washington College than at any other place he had lived. Sixteen months after moving in, he would die in the new house.

*L*ee was stricken as he was about to say grace before afternoon tea. He was unable to answer Mary's concerned questions, and she sent Custis to fetch the doctors. They said he had a "venous congestion of the brain," (now called a cerebral thrombosis) which meant a blood clot had lodged in his brain. This, combined with his heart condition and hardening arteries, were producing what his doctors termed "cerebral exhaustion." They ordered a bed to be brought down and placed in the dining room, and put Lee to bed in a comatose condition.

Weeks passed and Lee, seldom conscious, lay in the bed in the dining room. When awakened, he took medicines and food but had little interest in what was going on around him. He could speak when spoken to, but only in monosyllables. He seemed reconciled to his death.

Word of his condition spread throughout the world. Messages and offers of help poured in, but he was beyond all aid. When one of his doctors tried to arouse interest by saying that Traveller had been too long in the stable and needed exercise, Lee merely shook his head and closed his eyes.

On October 10 there was a change for the worse. Lee seemed to be suffering constant pain. He could not speak. He refused nourishment, and would take medicine only from the doctors. His friend, Colonel William Preston Johnston, was with him most of the night and later described those hours: "As the old hero lay in the darkened room, or with the lamp and the hearth-fire casting shadows upon his calm noble front, all the massive grandeur of his form, and face and brow remained; and death seemed to lose its terrors and to borrow a grace and dignity in sublime keeping with the life that was ebbing away."

During the next afternoon, Lee sank into a coma. Mary sat beside him in her wheelchair. In her words, "He wandered to those dreadful battlefields" — at one moment he cried out, "Tell Hill he *must* come up!" The last distinct words she heard him say were "Strike the tent!"

The next morning the family was beside him, silent. At nine o'clock Mildred saw that her father "seemed to be struggling. I rushed out for the doctor... he came, looked at him, and without saying a word walked quietly away. In a moment he was dead — "

Lee's one-room office on the lower level of the chapel at Washington and Lee University is preserved as it was when he left it for the last time. September 28, 1870, was a cold day and it began to rain in the afternoon. Lee left his office, went home, ate his midday dinner, and took a short nap. After attending a church vestry meeting, he was sitting down to tea when he suffered a seizure. Doctors were summoned, and he was made comfortable in the dining room. He was not to leave that room alive. On the morning of October 10, barely conscious, he said his last words, "Strike the tent!" Two day later he died.

*R*obert E. Lee died October 12, 1870, two days after a flood had swept the hill country. The local undertaker had no coffins, the three he had just received had been swept away from his river wharf. One was discovered washed ashore two miles downstream, but it was a bit too short; Lee was buried without his shoes.

The *New York Tribune* sent a special correspondent, who described the town in mourning: "... the only topic of conversation is the death of General Lee. All classes of the community seem to be affected, even the colored people, who walk along in silence with sorrowful countenance, and mourn the loss of 'Good ole Marse Robert.'... Many of the students [at Washington College] were affected to tears. They seemed to have had for General Lee the affection of children for a father.... The only sound breaking the silence of this twilight hour is the monotonous tolling of the bells, the knell of Lee."

Lee was taken to the college chapel, where he would lie in state, clad in an ordinary black suit. On the morning of October 15, the body of Robert E. Lee was carried in a last grand review through the narrow streets of Lexington. Buildings were draped. Crowds gathered to see the procession pass. Old soldiers wore a simple black ribbon in the lapels of their coats. A Virginia Military Institute battery fired cannon, and the cadet band played a dirge. Behind the hearse came Traveller, the trappings of mourning on his saddle.

The service was simple and brief, as he had wished. The coffin was covered with flowers and evergreens. There was no sermon. Reverend Pendleton read the burial service of the Episcopal Church.

"I am the resurrection and the life, saith the Lord: he that believeth in me, though he were dead, yet shall he live: and whosoever liveth and believeth in me, shall never die...

"Thou turnest man to destruction: again thou sayest, Come again, ye children of men. For a thousand years in thy sight are but as yesterday: seeing that is past as a watch in the night, As soon as thou scatterest them they are even as a sleep: and fade away suddenly like the grass. In the morning it is green, and groweth up; but in the evening it is cut down, dried, up and withered...

"O teach us to number our days: that we may apply our hearts unto wisdom. Glory be to the Father, and to the Son, and to the Holy Ghost; As it was in the beginning, is now, and ever shall be: world without end. Amen."

The casket was placed in a vault beneath the chapel, as the congregation sang one of Lee's favorite hymns, "How Firm a Foundation." The people filed past the tomb to pay their last respects, and the ceremony was over.

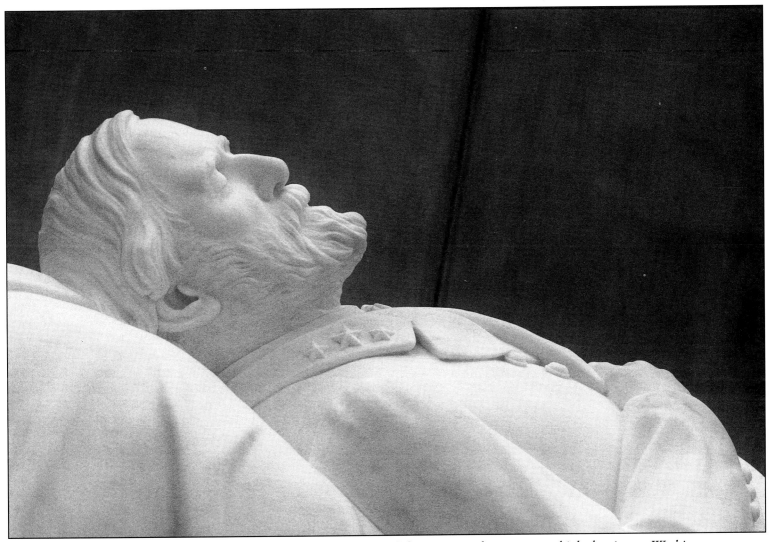

Lee's strength of character is reflected in a close-up of the famous life-size recumbent statue which dominates Washington College's Lee Chapel, only steps away from the house in which he died. A memorial was planned, the money was raised, and his widow, Ann, suggested it be sculpted by Edward V. Valentine of Richmond. The design was ready by 1872 and sculpted by 1875, three years after the college name was changed to Washington and Lee. Lee now rests in the family crypt in the basement of the chapel with his parents, his wife and children, and other relatives.

Epilogue

Statue at Hollywood Cemetery, Richmond

IN LIFE Robert E. Lee was a Southern hero; in death he was an American hero. A generation after Appomattox, historian James Ford Rhodes wrote that "... we should be willing now to recognize in him one of the finest products of American life."

Theodore Roosevelt said that Lee "will undoubtedly rank as without any exception the greatest of all the great captains that the English-speaking peoples have brought forth... a full equal of Marlborough and Wellington."

The British always respected Lee. Lord Acton called him "the greatest general the world has ever seen, with the possible exception of Napoleon." Lord Wolseley, who as a British general visited the Confederate army in 1862, wrote of his meeting with Lee: "He was the ablest general, and to me

seemed the greatest man I had ever conversed with... General Lee was one of the few men who ever seriously impressed and awed me with their natural and inherent greatness."

One of Lee's greatest admirers was a man who had been his enemy on the battlefield: Charles Francis Adams, Jr., who was a colonel in the Union army, son of the U.S. Ambassador to the Court of St. James during the war, grandson of the sixth President, and great-grandson of the second President. In a 1901 speech, Adams gave credit to Lee for terminating the war when he did rather than letting it drag on in a series of guerrilla encounters.

Adams said of Lee: "There was about him nothing venal, nothing querulous, nothing in any way sordid or disappointing... the most priceless of [his] contributions were contained in the precepts he inculcated and in the unconscious example he set during those closing years."

In 1907, the hundredth anniversary of Lee's birth, Julie Ward Howe prepared these new verses for her "Battle Hymn of the Republic:

A gallant foeman in the fight,
A brother when the fight was o'er,
The hand that led the host with might
The blessed torch of learning bore.
No shriek of shells nor roll of drums,
No challenge fierce, resounding far,
When reconciling Wisdom comes
To heal the cruel wounds of war.
Thought may the minds of men divide,
Love makes the heart of nations one,
And so, they soldier grave beside,
We honor thee, Virginia's son.

After many years had passed, the man who had often been denounced in the North as a traitor was finally recognized for his true worth. Had he died during the Appomattox Campaign, he might have been remembered simply as a capable general who could not win a war against hopeless odds.

What Lee did on the battlefield made him famous, but what he did after the war made him great. Lee the soldier is a dramatic figure; Lee the educator is more human, more appealing. His essential kindness and goodness found expression as he presided over a struggling little college. There the man who led so many young men to their deaths led other young men to lives of service.

A Guide to
ROBERT E. LEE SITES

Antietam National Battlefield

The Battle of Antietam, called Sharpsburg in the South, was fought on September 17, 1862, and it was the bloodiest day of the war. More than 23,000 men were killed or wounded, the casualties equally divided between North and South. The battle was the climax of the first of two attempts by Lee to take the war to the North. He had several objectives—to encourage Northern anti-war sentiment, to gain the support of the border state of Maryland, to promote European recognition of the Confederacy, and to draw Federal troops away from Virginia.

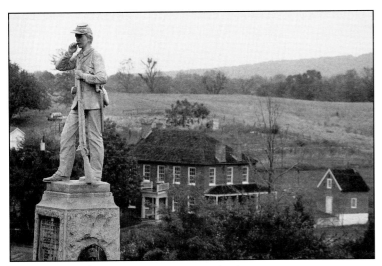

45th Pennsylvania Monument at Antietam

The course of the war was changed when Lee's 40,000-odd Confederates clashed with McClellan's 80,000-man Army of the Potomac. The battle was not a clear-cut Union victory, but it was close enough for Lincoln to issue the Emancipation Proclamation, which made freeing the slaves an issue in the war.

The battle, which encompassed a twelve-square-mile area, was fought in three phases—morning, midday and afternoon. At dawn Federal artillery struck at Stonewall Jackson's troops in a cornfield just north of town. Hooker's troops attacked the rebels, who drove them back. An hour later, a Federal counterattack regained some of the lost ground.

At mid-day fighting broke out in an area now called the West Woods near the Dunker Church, and Federals commanded by General Sedgwick suffered heavy casualties. General French's troops moved to support Sedgwick, resulting in the four-hour battle at Bloody Lane.

In the afternoon, General Burnside succeeded in crossing a stone bridge over Antietam Creek and advanced on Lee's right flank, just south of Sharpsburg. Then A.P. Hill's division, after a forced march from Harpers Ferry, arrived just in time to stop the Federal advance.

The battlefield is eleven miles south of Hagerstown, Maryland, off Route 65. The Visitor Center shows a twenty-six minute indoctrination film on the hour. Open daily from 8:30 a.m. to 5 p.m., 8 to 6 in the summer.

Appomattox Court House National Historical Park

Here on April 9, 1865, Lee surrendered the Army of Northern Virginia to Grant. His exhausted army was trying to make its way west to Danville pursued by two Union armies and Sheridan's cavalry.

The generals met at the home of Wilmer McLean. Grant's terms were generous, helping to bring about a reconciliation and reunification of the divided nation. At Lee's request, his men were allowed to keep their sidearms and baggage and take their horses to plow their fields. Grant sent food to Lee's army, and when his men began firing cannon to celebrate, he stopped them saying, "the rebels are our countrymen again, and the best sign of rejoicing... will be to abstain from all demonstrations." On April 12, as the remnants of Lee's army marched past Union ranks at Surrender Triangle, piling up their arms and battle flags, the Federal troops saluted them.

The village of Appomattox Court House has been restored and reconstructed to appear much as it did in 1865. Interpreters in period dress answer questions about the people who lived here and the events that took place. In addition to the McLean House and the Surrender Triangle, the buildings include the Appomattox Court House, Clover Hill Tavern, the Confederate Cemetery, the County Jail, the Woodson Law Office, the Meek's Store and Meek's Storehouse. The park, three miles northeast of the town of Appomattox on Route 24, is open from 9 a.m. to 5 p.m. daily.

Sayler's Creek Battlefield State Historical Park. Spring rain turned the roads to mud as Lee pushed west, and his supply wagons were mired at Sayler's Creek. The last major battle of the war was fought here on April 6, 1865. Federal

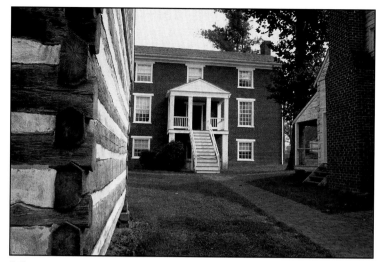

The Court House at Appomattox

troops fired on Confederates at the Hillman house, and after a spirited clash Ewell and Anderson surrendered half of Lee's army. Appomattox now was only seventy-two hours away. The Hillman House, used as a hospital during the battle, is open for living history programs in the summer. The battlefield is on Route 617, six miles north of the intersection with Route 307. The Hillman House is on the right.

Alexandria

Across the Potomac from Washington, Alexandria became vulnerable when Virginia seceded from the Union. The city dispatched four companies to the Confederate army before it was occupied in May 1861. It escaped destruction by being safely behind the lines for the remainder of the war, although its use as a Federal supply base, hospital depot, and port of embarkation greatly changed its prewar appearance. There are several sites relating to Lee.

Boyhood Home. After leaving Stratford Hall, Lee lived in several Alexandria houses with his mother, brothers and sisters, including this stately, brick Federal townhouse, which was owned by a relative, William Henry Fitzhugh. Earlier the house had been visited by such notables as George Washington and Lafayette. Benjamin Hallowell, a Quaker educator, lived next door and helped Robert prepare for West Point. The house is furnished with period furniture and paintings. Open 10 a.m. to 4 p.m. daily. 607 Oronoco Street.

Christ Church. Lee was confirmed in the Episcopal faith here, and this is where he attended church as a boy and young man. Legend has it that on the third Sunday in April 1861, the day after he resigned from the army, Lee was approached in the churchyard after services by a contingent from Richmond and offered the command of the Virginia armed forces. The finest families of Alexandria, including the Washingtons and the Lees, worshipped in this

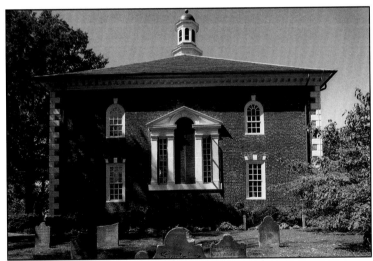

Church Lee attended in Alexandria

landmark 1773 Episcopal church. The church's cemetery was the town's burying ground until 1815. Open daily, except during services. 118 North Washington Street.

17th Virginia Infantry Monument. Most of Alexandria's fighting men joined the 17th Infantry Regiment. A stone obelisk, located in the middle of the city's main street, marked the spot where the first volunteers formed to march off to meet a Federal threat at Manassas. Washington and Prince streets.

Stabler-Leadbetter Apothecary Store. Lee was a regular customer here, as were George Washington and John Calhoun. According to a plaque on an outside wall, Lee was shopping here when Lieutenant Jeb Stuart handed him a message from the Secretary of War directing Colonel Lee to proceed at once to quell a disturbance by John Brown at Harpers Ferry. The shop is now a museum of early pharmacy, and displays a collection of more than a thousand apothecary bottles. Open daily except Sunday. 105 South Fairfax Street.

Arlington

Arlington House. Also known as the Robert E. Lee Memorial, this was the home of George Washington Parke Custis, Martha Washington's grandson, whom George Washington adopted. The magnificent house was designed by George Hadfield, a British architect who also worked on the Capitol, across the Potomac River in Washington. Construction began in 1801 and was completed in 1817.

In 1831, Robert E. Lee married Custis's daughter, Mary, here. The Lees always regarded this house as their permanent home. In April 1861, Lee was here when he made his decision to resign his commission in the army and serve with the forces of Virginia. During the war, the federal government seized the property on the technicality that the

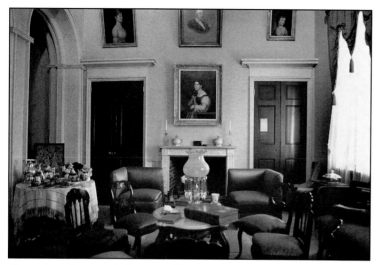
Drawing Room, Arlington House

taxes on it had not been paid in person by the owner and established Arlington National Cemetery on the grounds.

Arlington House, now administered by the National Park Service, is furnished with many items owned by the Lees, along with some Custis furnishings. The morning room displays some of the historical paintings Custis created to glorify the deeds of his adoptive father. The house is open daily, and reached through the Arlington National Cemetery entrance, off the George Washington Memorial Parkway.

Fredericksburg

When war came, this was a quiet town of 5,000 inhabitants, mid-way between Washington and Richmond, on a railroad, and protected by the Rappahannock and Rapidan Rivers. Its strategic location made it one of the main barriers to a Union invasion. Engulfed by the war, Fredericksburg would change hands seven times. Four great battles—the heaviest, most concentrated fighting ever seen on the continent—were fought in and around Fredericksburg between December 1862 and May 1863. The battles, in which casualties exceeded 100,000, were all distinguished by the military genius of Lee.

Fredericksburg and Spotsylvania County Battlefields Memorial National Military Park. This park is situated on 5,900 acres and includes parts of all four battlefields, the Fredericksburg National Cemetery, the house near Guinea Station where Stonewall Jackson died, Old Salem Church, and Chatham Manor. Miles of trenches and gun pits are accessible from the park roads. One visitor center is in Fredericksburg, on U.S. 1, at the foot of Marye's Heights. Another is at the Chancellorsville battlefield, ten miles west of Fredericksburg on Route 3. Both centers are open daily and have museums containing artifacts of the war, interpretive exhibits, and living-history demonstrations in the summer.

The first large-scale struggle for control of Fredericksburg occurred on a cold Saturday in December 1862. Burnside sent Federal troops on more than a dozen assaults against Lee's strong position at Marye's Heights. Federal losses exceeded 12,000 men; Lee's losses were less than half that number. In May 1863, as part of the Chancellorsville campaign, Federal troops under Hooker again attacked Marye's Heights. This time they were successful in driving the rebels from their positions.

The visitor center is the starting point for touring these sites. A seven-mile drive provides an almost constant view of Confederate trenches. The **Confederate Cemetery** is about a mile to the east at the intersection of William and Washington streets, in the midst of what were the Union positions on the plain. Six generals are among 2,000 Confederates buried here.

A view of Fredericksburg from Chatham Manor

Chatham Manor. This 18th-century Georgian mansion was the home of William Fitzhugh, one of the wealthiest landowners in Virginia, and a cousin of the Lees. Lee is believed to have met his future wife at a party here when they were both teenagers. In 1862 it became a frontline headquarters for various Union generals. Two pontoon bridges spanned the river below the mansion. The house also served as a field hospital in which hundreds of Union soldiers received treatment from regular medical personnel and volunteers like Clara Barton and Walt Whitman. Chatham Manor is just across the river from town, off Route 3. Open daily.

Chancellorsville. This battle site is located in a seventy-two-square-mile are of dense woods and thick underbrush known as the Wilderness. Here Hooker's attempt to turn Lee's left flank inexplicably lost its momentum. Then Lee, though badly outnumbered, split his army, dispatching Stonewall Jackson on a march behind the Union army that caught Hooker by surprise. The battle began with skirmishes on May 1, 1863, and lasted the better part of three days. The irreplaceable Jackson, accidentally shot by his own men was among the fatalities.

The visitor center at Chancellorsville provides an excellent introduction to the battle considered Lee's greatest victory. A self-guided auto tour of the battle starts at the center. The route of Jackson's twelve -mile flank march can be followed on foot.

Guinea Station. After he was shot at Chancellorsville, Jackson was brought by wagon to the railhead here to be taken by train to Richmond. He was too weak to move and was put to bed in the white clapboard office building of the Chandler plantation. He contracted pneumonia and died on May 10, 1863. The room in which he died looks as it did on that fateful afternoon. Now called the Jackson Shrine, the building and grounds are maintained by the

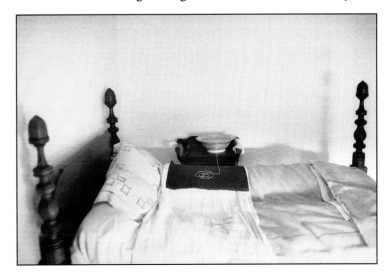

Bed where Jackson died

National Park Service. The Shrine is near the Thornburg exit off I-95.

Salem Church. This modest structure, built in 1844, was the focal point of bitter fighting on May 3-4, 1863, as Union reinforcements from Fredericksburg sought to come to the aid of Hooker at Chancellorsville.

Wilderness Battlefield. Lee would fight again in this unfriendly terrain. In 1864, the Army of the Potomac, with Grant personally directing its operations, started southward again. Using a strategy similar to Hooker's the year before, Grant tried to turn Lee's flank. On May 4, the Federals moved into the darkness of the Wilderness, where Lee was waiting. The next two days saw 182,000 men viciously fighting in woods often set afire by bullets. The battle produced 26,000-odd casualties, but only a momentary check to Grant's advance.

Bits and pieces of the Wilderness battlefield are all that remains. Park Service roads traverse part of the area, giving access to a few roadside markers and monuments. Open daily.

Spotsylvania. After the Wilderness, Grant and Lee raced to control the vital road junction at Spotsylvania Court House. Lee arrived first and hastily constructed earthworks. During the next fourteen days, May 8-21, repeated Federal attacks were made in an effort to break the Confederate lines. The bloodiest fighting of the campaign came in the rain on May 12, when bluecoats temporarily overran a salient whose northwestern face was known thereafter as the "Bloody Angle."

Spotsylvania today is among the most impressive sites of the war. A walking tour has been developed for the "Bloody Angle" area. To reach Spotsylvania following

Grant's route, proceed west from Chancellorsville on Route 3 to the intersection with County 613; turn south on 613 and continue fourteen miles to the exhibit shelter.

Gettysburg

Gettysburg National Military Park. In early June 1863, a month after his triumph at Chancellorsville, Lee led his army through the gaps of the Blue Ridge Mountains and north into Maryland and Pennsylvania. In pursuit was the Army of the Potomac, now commanded by George Meade. The armies met at Gettysburg quite by accident. The little village had a tannery, and a Confederate brigade was searching for shoes when it happened upon Federal cavalry.

On the first day, July 1, Lee attacked the Union forces on McPherson Ridge, just west of town, driving them to Cemetery Hill, south of town. On the second day, the armies were situated about a mile apart on parallel ridges—Meade on Cemetery Ridge, Lee on Seminary Ridge. Lee

Little clump of trees, Gettysburg

Massachusetts Sharpshooter Statue at Gettysburg

launched an attack against both Federal flanks. Longstreet hit the left flank, leaving the base of Little Round Top in shambles. He left Federal dead in the Wheatfield, and then overran the Peach Orchard. Ewell struck the Federal right in the evening at East Cemetery Hill and Culp's Hill.

The fateful third day began with a thundering, two-hour artillery duel. Lee bombarded Federal lines on Cemetery Ridge and Cemetery Hill; Meade struck at the rebels on Seminary Ridge. Then Lee sent 15,000-odd troops across the open field toward the Union lines, an assault known as Pickett's Charge. It was a slaughter; less than half of the rebels were able to make it back to their lines. The charge was the "high water mark of the Confederacy," marking the end of Lee's second and final attempt to invade the North. Lee suffered 30,000 casualties; the North 23,000. Lee's army moved south the next day. Meade did not pursue him.

The battlefield may be visited in a self-guided auto tour or with a licensed guide from the Visitor Center. Lincoln delivered his Gettysburg Address at the dedication of the national cemetery, which is across the street from the visitor center. At the center an electronic map vividly demonstrates troop movements during the battle, and the cyclorama at the center has a five-minute film. Gift shop and book store. The Visitor Center is open daily from 8 a.m. to 5 p.m.

Lexington

The campus of **Washington and Lee University** is as stately and genteel as Lee himself. He came here soon after the war and served as its president until his death five years later at the age of 63. Lee's office in the basement of the Lee Chapel on the campus remains intact, chairs still drawn up around a small conference table. Also in the basement is a museum of college mementos, with an emphasis on Lee contributions.

Down the hall from the office Lee's remains are entombed in a family crypt. Nearby are hung the Pine portrait of Lee and the famous Peale portrait of the young George Washington. In the chapel is the famous recumbent statue of Lee sculpted by Edward Valentine. He lies with one hand on his chest, his face tranquil but ravaged by the years of war. The remains of his trusted horse, Traveller, are buried outside the chapel. A few steps away from the chapel is the house where the Lees lived.

The Lee Chapel is open daily except for Thanksgiving and Christmas. One block west of Main Street on Henry Street is the visitor parking lot beside the chapel.

Cheek to jowl with Washington and Lee is the **Virginia Military Institute**, founded in 1839, the first state military college in the country. The school contributed a host of officers and men to the Confederate cause, including Lee's most trusted lieutenant, Thomas "Stonewall" Jackson, who

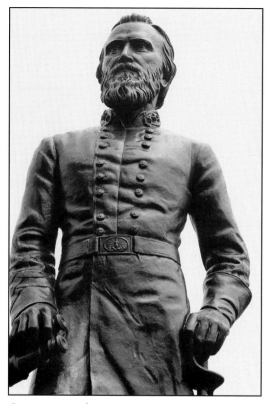
Statue at Jackson gravesite, Lexington

taught here before the war. His statue now stands at the center of the campus, overlooking the parade ground. On the east side of the parade ground stands Sir Moses Ezekiel's seated statue of *Virginia Mourning Her Dead*, a monument to the VMI cadets who fell in the 1864 battle of New Market. Mementos of Jackson are on display in the campus museum.

The museum is open daily, except Thanksgiving and Christmas. Dress parades are held Friday afternoons, September through may, weather permitting. VMI is north and adjacent to Washington and Lee University. North Main Street passes to the east of the parade ground.

The only house Jackson ever owned, a simple brick townhouse, has been restored to its appearance of 1859-61 and furnished with Jackson furniture memorabilia. There are guided tours and an interpretive slide presentation. Open daily except major holidays. Stonewall Jackson, members of his family, and some 400 other Confederate soldiers are buried in the **Stonewall Jackson Memorial Cemetery**, located in the 300 block of South Main Street.

Manassas

It is hard for the visitor to the **Manassas National Battlefield Park** to believe that this was the setting for two pivotal battles of the war. The manicured green hills, the clusters of trees, the little creek called Bull—all speak of tranquility and not the carnage of war. Yet 28,000 men were killed or wounded here in struggles to control a strategic railroad junction. Today the only reminders of strife are the cannon and the statues, particularly the larger than life equestrian statue where Jackson earned the sobriquet "Stonewall" while holding his regiment firm on Henry House Hill. That incident occurred in the first battle, on July 21, 1861, a confused affair fought by poorly trained volunteers. Confederate reinforcements arrived by train just in time to carry the day.

Lee did not fight in that battle, but the second battle here, on August 28-30, 1862, was one of his greatest victories. With the help of Stonewall Jackson he out-maneuvered and out-fought General John Pope's Army of the Potomac, clearing the way for a Confederate invasion of Maryland.

The Visitor Center, on Henry Hill, affords a view of much of the battlefield. Self-guided tours start here (a

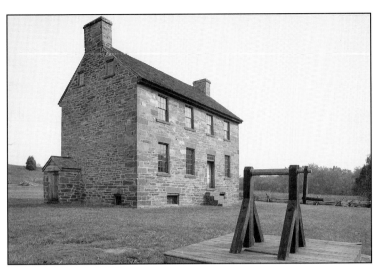
Stone House at Manassass

walking tour of First Manassas, driving tour of Second Manassas). Rangers lead tours in the summer. In the building is the Battlefield Museum with exhibits and an informative audiovisual presentation.

Among the sights are the Stone Bridge, where Union artillery opened the first battle and over which Union troops retreated after both battles; the Unfinished Railroad, behind which Jackson's men were positioned during the second battle; the Chinn House Ruins, a house that marked the left of the Confederate line in the first battle was the scene of Longstreet's counterattack in the second; and the Stone House, a tavern used as a field hospital in both battles.

The 3,100-acre park is 26 miles southwest of Washington, DC, near the intersection of I-66 and Route 234. The park is open daily, 8 a.m. to 5 p.m., to 6 p.m. in the summer. Re-enactments are held by private groups on Memorial Day weekend (for the first battle) and in late August (for the second battle).

Petersburg

Next to Richmond, this city was the scene of more action in the war than any other community in Virginia. The nine-month siege in 1864-65 remains the longest such operation on American soil. Some thirty-five miles of parallel earthworks extended in unbroken lines from east of Richmond to southwest of Petersburg. Constant pounding of Lee's thin but defiant ranks produced more than 65,000 Federal and Southern casualties. General John B. Gordon noted that "Lee's Miserables" were occupied in "fighting famine from within and Grant from without." The dozens of engagements fought around Petersburg make the area the largest battlefield in America.

Petersburg National Battlefield. From the visitor center where a seventeen-minute indoctrination describes the battles and the complexities of the siege, a four-mile driving tour winds through the park's main unit. The stops include Batteries 8 and 9, both captured by black Federal troops; Harrison Creek, where Confederate troops, driven back in the opening battle, dug in and held; Fort Stedman, a Union stronghold which Lee attacked on March 25, 1865, to relieve heavy pressure west of the city; Fort Haskell, where Federal artillery and infantry stopped Lee's southward advance during the Battle of Fort Stedman; Taylor Farm Site, where nearly 200 pieces of artillery were concentrated during the Battle of the Crater; and the Crater itself, where explosives were detonated under a Confederate fort, but an infantry attack failed in one of the bizarre episodes of the war.

An additional sixteen-mile motor tour takes you to park areas south and west of Petersburg. Begin at the exit of the main unit, turn left onto Crater Road (US 301), which is the original Jerusalem Plank Road of the war period, one of the main roadways leading into the city from the

southeast. Union earthworks were located to the left of the road; Confederate earthworks to the right.

The well-marked stops include the site of Fort Sedgwick, the key Federal post along the eastern portion of the siege line, nicknamed "Fort Hell" because of heavy Confederate mortar and sniper fire; Fort Wadsworth, where the Hagood Monument memorializes the South Carolina soldiers who broke through the Union line here; Forts Urmston and Conahey, built on ground captured by Federals during the Battle of Peeble Farm; Fort Fisher, the largest earthen fortification on the Petersburg front; Fort Gregg, the Confederate fort which guarded the western approach to Petersburg; and Five Forks, where Grant's forces broke through Pickett's line on March 29, 1865. The next day Grant assaulted Petersburg and the city was evacuated that night.

City Point Unit. Between June 1864 and April 1865, Grant made his headquarters in a log cabin on the lawn at Appomattox Manor plantation, where tents and cabins occupied nearly every square foot of ground. It became a nerve center for the Federal war effort, and turned a sleepy village into a bustling supply center for the 100,000 Union troops on the siege lines. From here the Union telegraph system provided the rapid transfer of information to all field commanders and Washington, enabling Grant to coordinate operations in all theaters of the war. On Cedar Lane in Hopewell, eight miles east of Petersburg.

The Visitor center is two and one-half miles east of the center of Petersburg on Route 36. East of the Center, is the City Point Unit in the city of Hopewell, at the corner of Pecan Avenue and Cedar Lane. Appomattox Manor, ancestral home of the Eppes family, is on the grounds and open to the public. The battlefield is open daily. From mid-June to late August, demonstrations are given of soldiers' life and mortars and cannon are fired.

Blandford Church. This old church, built in 1735 and abandoned when the town of Blandford was absorbed by Petersburg, was restored by the Ladies Memorial Association of Petersburg as a shrine to the 30,000 Southern soldiers buried in the church cemetery. Louis Comfort Tiffany designed a series of magnificent stained-glass windows of the Apostles, each donated by a former Confederate state in honor of its native sons who died in the war. Over the main door is the only Tiffany window that contains the Confederate battle flag. Tours daily. 111 Rochelle Lane, off Crater Road.

Violet Bank. Robert E. Lee made his headquarters on the lawn of this plantation from June 8 to November 1, 1864, when the falling leaves of autumn exposed his position to the enemy, making it necessary for him to move his encampment elsewhere. He was encamped here on the morning of July 30, 1864, when he received news of the explosion at the Crater. The large living room has been restored with Adamesque ceiling ornamentation and pieces of furniture, which are reproductions of the period around 1815. A small museum contains weapons and equipment carried by Confederate soldiers, cannon projectiles, and other items of interest. Violet Bank is one mile north of Petersburg, off Route 301 and I-95. Open Tuesday through Saturday and Sunday afternoon.

St. Paul's Episcopal Church. A marker denotes the pew where Lee worshipped during the nine-month siege. Two Confederate generals—Lee's son "Rooney" (William H. F.) and George E. Pickett were married in this church. In a nave is a stained-glass window dedicated to Lee's memory. 110 North Union Street. Open daily.

Richmond

This city was the heart of the Confederacy, the capital of both the Southern nation and its most important state. Richmond also became the chief manufacturing center in the wartime South, the major rail junction in the Upper South, and as a result the sole target of the North's principal army. Major campaigns in 1862 and 1864-65, numerous Federal raids, and a population that quadrupled from 1860 to 1865 kept the city in turmoil. Yet it stood proud and

Great Seal of the Confederacy

defiant until it was abandoned in April 1865. Today it has more historical attractions than any other city in the South.

Monument Avenue. A ceremonial entrance to the city, running between Lombard and Belmont streets, this broad avenue, laid out in 1885, is lined with handsome residences. The Lee Statue is at the intersection of Allen Street; the J.E.B. Stuart statue at Lombard Street (Stuart died at his brother-in-law's home on nearby Grace Street); the Jefferson Davis Statue at Davis Avenue, and the Stonewall Jackson statue at the Boulevard. The Lee statue was dedicated before a crowd of Confederate veterans in 1890, when the area was still an open field.

Virginia State Capital. Once the Capitol of the Confederacy, this is the meeting place of the Virginia General Assembly, the oldest lawmaking body in the western hemisphere. Thomas Jefferson designed the building. The Virginia secession convention was held here in 1861, and Lee appeared before the convention to accept command of the

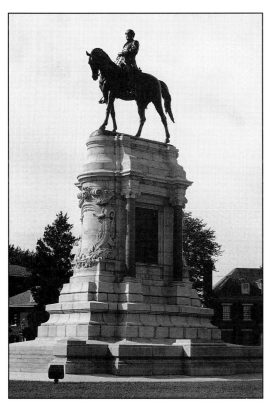

Lee Statue on Monument Avenue

armed forces of Virginia. The Hall of the House of Delegates contains statues of Generals Lee, Jackson, Stuart, Joseph E. Johnston and Fitzhugh Lee, President Jefferson Davis and Vice President Alexander H. Stephens. The statue of Jackson on the grounds, a gift of "Some English Gentlemen," was the first Confederate hero's monument erected in Richmond. Davis delivered his inaugural address from the Washington statue on the grounds. Capitol tours are given Monday through Saturday and Sunday afternoons, Capitol Square.

St. Paul's Church. Lee and President Davis attended this Greek Revival church, now known as the "Cathedral of the Confederacy." Pews used by Davis and Lee are marked. Next to the Lee pew is the handsome Lee Memorial Window. During services on the first Sunday in April 1865, Davis received a note that Lee's lines were broken at Petersburg, and he should evacuate Richmond immediately. The church, across the street from Capitol Square, is open

Jefferson Davis's office in his Richmond home

daily. A brief church tour is offered each Sunday following the 11 a.m. service. 815 East Grace Street.

White House of the Confederacy. The house that Davis lived in during the war was built in 1818 for Dr. John Brockenbrough. When the Confederate government moved here from Montgomery, the city of Richmond purchased the house and rented it to the Confederacy. Ten rooms have been restored to their wartime appearance. The second floor holds Davis's office, the master bedroom and the nursery. Two children were born to the Davises in the house. Tragedy also visited the Davises here: in 1864 their five-year-old son Joe was killed in a fall from the east portico.

Museum of the Confederacy. The nation's largest collection of Confederate artifacts, including weapons, uniforms, battle flags, letters, diaries, and photographs is in a handsome new building across from the White House of the Confederacy. Among the displays are Lee's field equipment (bed, saddle, clothing, field glasses and other items)

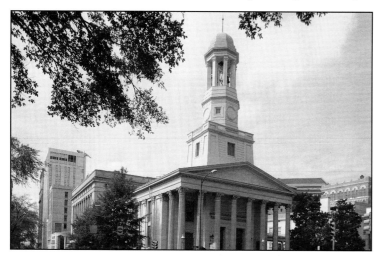

St. Paul's Church, where Davis learned of the fall of Petersburg

In Search of Robert E. Lee

Confederate Battle Flag

Hollywood Cemetery, Richmond

and the sword he wore at Appomattox. Museum shop. The White House and the museum are both open daily. 1202 East Clay Street.

Lee House. This 1844 Greek Revival house was the wartime home of the Lee family. Lee came here after surrendering his army at Appomattox in April 1865. One of the most famous photographs of Lee was made here on the back porch after Matthew Brady persuaded him to pose. Lee and his family soon moved to Lexington after he accepted the presidency of Washington College (now Washington and Lee). The house is not open to the public. 707 East Franklin Street.

Hollywood Cemetery. Confederate President Davis, two U.S. Presidents, James Monroe and John Tyler, Generals J.E.B. Stuart and George Pickett are here with 18,000 Confederate soldiers, including more than 2,000 removed from the Gettysburg battlefield. The southern section of the cemetery overlooks the James River and affords some of the best views of the river and the city skyline. Maps are

available at the office just inside the gate. There is only one entrance to this private cemetery. Take Belvidere Street (U.S. 1) south toward the river, turn right on Spring Street, go three blocks to Cherry Street then turn right. The entrance is on the left at Albemarle. Open daily. Cherry and Albemarle streets.

Richmond National Battlefield Park

This park preserves ten sites on 768 acres in three counties. The sites are associated with McClellan's 1862 Peninsula Campaign, the Seven Days, and Grant's campaign of 1864. A driving tour of the sites covers about sixty miles, a hundred miles, if a visit to Drewry's Bluff on the south side of the James River is included.

A map for the tour is available at the visitor center at 3215 East Broad Street, which is located on the site of the Chimborazo Hospital, the chief medical center of the Confederacy, then one of the largest military hospitals in

the world. Exhibits describe the hospital and the defense of the city.

Chickahominy Bluff. On the James River were part of the Confederate defenses during the 1862 campaign. Lee observed the first battle of the Seven Days from this vantage point.

Cold Harbor. In the 1864 campaign, Grant, having failed to dislodge Lee from Spotsylvania, marched his army south to Cold Harbor in another attempt to outflank Lee. Here Grant ordered a frontal assault against strong Confederate earthworks and suffered a costly defeat; 7,000 of this troops fell in one day. Grant later said he regretted this attack more than any other.

Seven Pines. In the battle here on April 31, 1862, General Joseph E. Johnston, severely wounded by a shell fragment in the chest, had to be relieved of his command. The next day President Davis appointed Lee commander of the Army of Northern Virginia. During the Seven Days' battles, June 25 to July 1, Lee, despite poor coordination, was able to roll back McClellan's numerically superior army at Gaines' Mill (Watt House) and Savage Station.

Glendale (Frayser's Farm). Federal troops protected the vital crossroads near the old Frayser Farm, "Glendale," while McClellan's retreating army snaked south toward Malvern Hill. Lee's troops repeatedly assaulted the position but failed to carry it. The next day, when a general remarked that it looked as if McClellan would get away, a frustrated and angry Lee snapped, "Yes, he will get away because I cannot have my orders carried out."

Malvern Hill. Federal troops occupied this area on June 30 as McClellan continued his retreat east. The Confederate attack on July 1 was a disaster, as waves of troops hurled themselves at the massed Federal artillery on the hill. A.P. Hill said that it "was not war—it was murder." Despite the

pleas of his officers, McClellan continued his retreat to the river landings at Berkeley Plantation.

Berkeley Plantation. This was the plantation of the Harrisons, the family that included a signer of the Declaration of Independence and two Presidents, William Henry and Benjamin Harrison. The land was part of a royal grant in 1619; the house was built in 1726. During the war, McClellan established his headquarters here at Harrison's Landing, as the plantation was then called, and Lincoln came to consult with McClellan and review the 140,000-odd troops. General Daniel Butterfield composed the bugle call "Taps" while he was staying here. After Lee drove McClellan from the gates of Richmond in the Seven Days, the Army of the Potomac retreated here to board ships to return to Washington. Berkeley Plantation is on Route 5 in Charles City County. Open daily.

Shirley Plantation. This graceful, three-story brick house on the James was the home of Robert E. Lee's mother. Construction of the house started in 1723 as a wedding present to his daughter, Elizabeth, and her new husband, John Carter. The eldest son of Robert "King" Carter, John held the post of secretary of Virginia and sat on the Governor's Council. Light-Horse Harry Lee, the governor of Virginia and a widower, married Charles Carter's daughter Ann at Shirley in June 1793. The Lees moved to Stratford Hall until Harry's financial reverses forced the family to move to Alexandria. Ann and the children spent extended periods at Shirley. Young Robert lived here for awhile and attended school with his cousins in one of the dependencies.

During the war, wounded Federal soldiers were brought to the lawn around the house after the Battle of Malvern Hill. Louise Carter wrote that "they lay all about on this lawn all up and down the river bank. Nurses went about

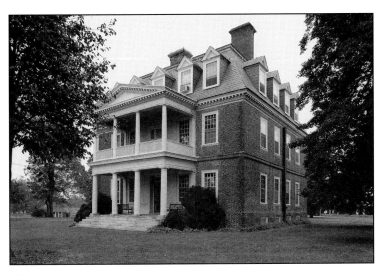

Shirley Plantation

with buckets of water and ladles for them to drink and bathe their faces... Mama had to tear up sheets and pillow cases to bind their wounds, and we made them soup and bread every day until they died or were carried away." McClellan sent a letter, "with the highest respect," thanking the Carters for their aid to men "whom you probably regard as bitter foes."

The house is distinguished by its paneling and the "flying" or "hanging" staircase, which rises from the ground floor to the attic without visible means of support. The 17th- to 19th-century furniture, silver, china, glassware and portraits are all family pieces. Shirley Plantation is off Route 5 in Charles City County. Open daily.

Stratford Hall. This plantation was the ancestral home of the Lees. Thomas Lee built the house in the 1730s, one of the great dynasties of America. Robert E. Lee was born here, January 19, 1807. Four years later, his father's disas-

trous speculation in land left him virtually penniless, forcing him to move the family to Alexandria.

The house is one of the grandest in Virginia, an H-shaped, fortress-like mansion with imposing chimney clusters. The formal rooms on the second floor include the handsomely paneled Great Room. The southeast bedroom, called the Mother's Room, is where many of the Lee children, including Robert, were born. On the ground floor are additional bedrooms and the estate's counting room. The house is furnished throughout with 18th- and early 19th-century antiques and family portraits.

The plantation, originally encompassing 16,000 acres, now consists of 1,600 acres. Besides the great house, there are a number of other original buildings—two dependencies, the kitchen, smoke house, spring houses, coach house, a working grist mill, slave quarters and stables. In the East Garden, restored in the 1930s by the Garden Club of Virginia, formal boxwoods in parterres descend to the

Stratford Hall

Lee family burial vault. The visitor center has a museum and a theater with an audio-visual presentation. Costumed docents conduct tours of the house and grounds. Stratford Hall is six miles north of Montross on Route 3 to Lerty, then east on Route 214. Open daily.

Washington, D.C.

Blair-Lee House. Lee was offered command of the Union armies in this 1824 townhouse by its owner, Montgomery Blair, Lincoln's postmaster general and a close advisor to the President. The government-owned house is used for visiting dignitaries. Closed to the public. 1651 Pennsylvania Avenue.

West Point

United States Military Academy. West Point has been of military importance since the Revolution. It was one of the four points on the mid-Hudson fortified against the British. In 1778 a great chain was strung across the river to stop British ships. The U. S. Military Academy was founded by an act of Congress in 1802. Lee, a member of the Class of 1829, returned in 1852 as the academy's superintendent. Open daily.

The visitor center has exhibits on cadet training, a model cadet room, a theater that shows films on various aspects of the academy, a gift shop and a book store. The

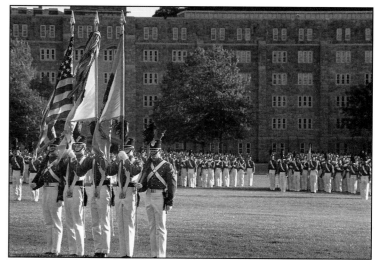

West Point

West Point Museum has exhibits on the army through history. It displays an excellent oil portrait of Lee when he was the superintendent here, and the sash he wore at the surrender at Appomattox. Overlooking the Hudson is the Battle Monument set on a single column. It honors regular army officers and enlisted men who fought for the Union and were killed in the war. Inscribed on the column are the names of the 2,230 men, by regiment. Nothing at the academy honors its graduates who fought for the Confederacy. The superintendent's house, facing the Plain, is not open to the public.

Index

Adams, Charles F., Jr., 100
Alexander, E. Porter, 11
Alexandria, VA, 16, 18, 102, 103
Amelia Court House, VA, 76, 78
Appomattox Manor Plantation, 72
Arlington, VA, 22, 46, 103-104
Aztec Club, 26

Banks, Nathaniel, 36, 38
Battles
 Antietam, 50, 101
 Appomattox, 78, 80, 82, 102
 Cedar Mountain, 44
 Chancellorsville, 56, 105
 Chickamauga, 34
 Cold Harbor, 68, 69, 114
 Cross Keys, 38
 Five Forks, 74
 Fredericksburg, 54, 104
 Front Royal, 38
 Gettysburg, 11, 26, 58-63, 106-107
 Kernstown, 38
 Malvern Hill, 11, 114
 Manassas (First), 36, 108-109
 Manassas (Second), 44, 108-109
 Nashville, 34
 Peninsula, 36
 Petersburg, 70, 72, 74, 76, 109-111

 Port Republic, 38
 Sayler's Creek, 78, 79, 102
 Seven Days, 40, 113-116
 Seven Pines/Fair Oaks, 36, 114
 South Mountain, 48
 Spotsylvania, 64, 66, 67, 106
 Wilderness, 64, 106
 Winchester, 38
 Yellow Tavern, 41, 66
Beauregard, Pierre G.T., 26, 42
Beecher, Henry W., 90
Benet, Stephen V., 10
Berkeley Hundred Plantation, 37, 114
Blair, Francis P., Sr., 33
Blair, Francis P., Jr., 32, 33
Blair House, Washington, 32, 33, 116
Brady, Matthew, 84
Bragg, Braxton, 42
Brown, John, 30, 32
Burnside, Ambrose E., 50, 52

Carter, Charles, 14
Catton, Bruce, 10
Chamberlain, Joshua L., 82
Chatham Mansion, 53, 105
Chesnut, Mary, 10
Christ Church, Alexandria, 28, 103

City Point, VA, 72
Cockspur Island, GA, 22
Cooper, Samuel, 34, 42
Custer, George A., 78
Custis, George Washington Parke, 22, 30

Davis, Jefferson, 20, 26, 28, 36, 42, 62, 74, 76, 84, 86
Derwent Estate, 86, 87
Douglas, Henry K., 82

Early, Jubal, 54, 58
Emancipation Proclamation, 50, 52, 101
Ewell, Richard S., 36, 58, 78
Ezekiel, Moses, 39, 108

Floyd, John, 30
Fort Hamilton, NY, 24
Fort Monroe, VA, 22, 24, 25
Fort Pulaski, GA, 22
Freeman, Douglas S., 10
Fremont, John C., 38

Georgetown, DC, 22
Gibbon, John, 34

Gordon, John B., 82

Grant, Ulysses S., 30, 64, 65, 66, 68, 70, 72, 78, 80, 84

Hancock, Winfield S., 26

Harpers Ferry, WV, 30, 48

Hill, A.P., 36, 50, 54, 58, 76

Hill, D.H., 36, 50

Hoke, Robert, 68

Holmes, Theophilus H., 20

Hood, John B., 28, 42

Hooker, Joseph, 26, 54, 56, 58

Howard, Oliver O., 28

Jackson, Thomas J. "Stonewall," 36, 38, 40, 44, 48, 54, 56, 57, 105

Johnston, Albert S., 21, 26, 42

Johnston, Joseph E., 20, 30, 32, 42, 78, 92

Johnston, William P., 94

Kirkland, Richard, 55

Law, Evander M., 68

Lee, Ann Carter, 14, 16, 18, 22

Lee, Fitzhugh, 28, 68

Lee, Francis Lightfoot, 14

Lee, George Washington Custis, 24, 28, 46, 85, 86, 88, 91, 94

Lee, Henry "Light-Horse Harry," 14, 16

Lee, Mary Anne Randolph Custis, 22, 24, 46, 86, 93, 94

Lee, Matilda, 14

Lee, Richard Henry, 14

Lee, Robert E.,
-and chess, 11, 22
-and children, 11, 24
-and John Brown raid, 30, 32
-and his horse Traveller, 80, 86, 88, 92, 94
-and music, 11
-and religion, 28, 44
-and 2nd Cavalry, 28, 32
-and Virginia, 24, 32, 34, 84, 90
-appearance, 14, 20, 28, 32, 80, 92
-as General in Chief, 74
-as junior officer, 24
-as president of Washington College, 88, 90, 91, 92, 93, 95
-at West Point (as cadet), 20
-at West Point (as Superintendent), 28, 88
-attitude toward secession, 34, 90
-attitude toward slavery, 34
-birth, 14
-character, 11, 30
-education, 18
-evaluation of his military ability, 10-11, 42, 99-100
-final illness, 94-95
-financial concerns, 16, 22, 24, 28
-funeral, 96
-in Mexican War, 26
-in early months of Civil War, 36
-in Seven Days battles, 40
-lineage, 14
-physical strength, 14
-reorganization of troops after Antietam, 52
-reorganization of troops after Chancellorsville, 58
-temperament, 42
-wartime Richmond residence, 84, 85, 113

Lee, William H.F. "Rooney," 28

Lexington, VA, 107-109
Grace Church, 88, 92
Lee Chapel, 91, 92, 95, 97
Stonewall Jackson Memorial Cemetery, 108
Virginia Military Institute, 38, 39, 88, 107-108
Washington and Lee University (earlier Liberty Hall and Washington College), 88, 89, 90, 93, 107

Lincoln, Abraham, 72, 74, 84

Longstreet, James, 26, 36, 54, 58, 60, 76

Lynchburg, VA, 78

Magruder, John B., 21

Marshall, Charles, 11

McClellan, George B., 26, 30, 36, 40, 42, 44, 48, 50

McCormick, Cyrus, 90

McDowell, Irwin, 36, 38

McLean House, Appomattox, 80, 81, 102

McPherson, James B., 28

Meade, George G., 58, 62, 69

Mercie, Jean A., 9

Peabody, George, 90
Pelham, John, 54

Pemberton, John, 34
Pendleton, William N., 21, 88, 96
Pickett, George E., 60, 62, 74
Polk, Leonidas, 21
Pope, John, 44

Richmond, VA, 76, 84, 111-116
 Hollywood Cemetery, 113
 Lee House, 84, 85, 113
 Monument Avenue, 9, 41, 111
 Museum of the Confederacy, 112
 St. Paul's Church, 76, 112
 State Capitol, 35, 111
 Tredegar Iron Works, 34
 White House of the Confederacy,
 112-113

Savannah, GA, 22
Schofield, John M., 28
Scott, Winfield, 26, 28, 32, 34
Sharpsburg, MD, 48
Shenandoah Valley, 38
Sheridan, Philip H., 28, 66, 68, 78
Sherman, William T., 30
Shields, James, 38
Shirley Plantation, 14, 18, 114-115
St. Louis, MO, 24
Stratford Hall, 14, 16, 115-116
Stuart, J.E.B., 28, 30, 36, 40, 41, 58,
 66, 103

Taylor, Walter H., 70
Thomas, George H., 26, 34

Units, Confederate
 Army of Northern Virginia, 11, 44,
 48, 52, 58, 82
 First Corps, 58
 Second Corps, 58, 66

Third Corps, 58
Stonewall Brigade, 82
11th North Carolina, 62
38th North Carolina, 62
17th Virginia, 103
Washington Artillery, 75
Units, Union
 Army of the Potomac, 52, 54, 56,
 101
 5th New Jersey, 67
 45th Pennsylvania, 101
 69th Pennsylvania, 8

Valentine, Edward, 92, 97
Violet Bank Plantation, 70, 77
Virginia, 34

Warren, Gouverneur K., 59
West Point, NY, 18, 116
Wilcox, Cadmus M., 62